GHOSTS OF
ST. CHARLES

GHOSTS OF ST. CHARLES

MICHAEL HENRY

Haunted
America

Published by Haunted America

A Division of The History Press

Charleston, SC 29403

www.historypress.net

First published 2010

Second printing 2011

Third printing 2012

Fourth printing 2013

Manufactured in the United States

ISBN 978.1.60949.019.5

Library of Congress Cataloging-in-Publication Data

Henry, Michael.
Ghosts of St. Charles / Michael Henry.
p. cm.
ISBN 978-1-60949-019-5
1. Ghosts--Missouri--Saint Charles. I. Title. II. Title: Ghosts of Saint Charles.
BF1472.U6H46 2010
133.109778'39--dc22
2010027751

To the women who created me:

Carla Henry, my wife
Carolyn Scott, my mentor
Karen Johnson, my teacher
Teri Baker, my best friend

CONTENTS

INTRODUCTION

In 1803, the United States purchased 828,800 square miles of land from France. This transaction, known as the Louisiana Purchase, doubled the size of the United States. The U.S. government paid 60 million francs ($11,250,000), plus cancellation of debts worth 18 million francs ($3,750,000), for a total of about $15 million. On March 10, 1804, a formal ceremony was conducted in St. Louis to transfer ownership of the territory, effective October 1, 1804.

The eastern boundary of the Louisiana Purchase was the Mississippi River, from its source, to the 31^{st} parallel. (However, the source of the Mississippi was unknown at that time). The western boundary was unknown, but according to the treaty, it followed the Sabine River to the 32^{nd} parallel, ran due north to the Red River and then followed the 100^{th} meridian along the Arkansas River to its headwaters. From there, it ran due north to the 42^{nd} parallel and west to the Pacific Ocean.

Cahokia, founded in 1699, is the earliest French settlement still in existence. Soon after, Kaskaskia was established (1703), followed by a series of other east bank towns (modern Illinois) at Prairie du Pont, Fort Chartres and Fort Vincennes on the Wabash. Settlements by the French on the west bank of the Mississippi (modern Missouri) include Ste. Genevieve and New Madrid (then known as *Ainse de la Graise* or "Greasy Bend"). These were followed by St. Louis, St. Charles, Carondelet, St. Ferdinand (now Florissant) and Portage des Sioux.

St. Louis was founded in November 1763, when Pierre Laclède Liguest and his band of traders from New Orleans landed "where a small creek flowed into the Mississippi river." Though not spectacular, the village's growth was steady in the later years of the eighteenth century. The Mississippi River was narrow and swift, but the frontier trading post soon became the most important village for hundreds of miles around. A short distance upstream, the Missouri and Mississippi Rivers meet. The Illinois, Meramec and Ohio Rivers all contribute to the flow. Intrepid adventurers soon made their way up the Missouri River to establish St. Charles. In the days when the primary means of transportation was water, it made perfect sense to establish an outpost here.

The first western settler built a permanent structure in St. Charles about 1750. At that time, the settlement was called *Les Petite Cotes* (Little Hills). Soon after, there was a dispute over the ownership of the property, and rather than fight, this first resident simply moved on. We know only that he was French and his wife was Native American. His name and his legacy are lost to history.

According to tradition, in 1769, Louis Blanchette built a log cabin at the future St. Charles, on the banks of the Missouri River. After spending several months here, he saw great possibilities in fur trading. He went back to Canada, and the following spring, he and his followers established the Fur Trading Post. This was the only "white man's" settlement in the vast wilderness extending north from Canada and west from the Mississippi to the Pacific. From this secure location, Canadian voyagers laden with goods for Native American trade departed and then returned with furs. The first fur transaction, translated from the original French, reads:

I received from Jean Baptist Pillier for the account of Baptist Point duSable three packs of cats—six deer skins and color of which are [?]. A dozen eggs from Monsieur Pellier for having brought the three packs from Chicago the 30th of June 1796 for Francois Drugette [Signed] Jean Baptist Gigon

In 1789, Blanchette was the first of three commandants appointed by the Spanish. In contrast, the residents of the area were French in both language and culture.

In 1793, a brick structure was built on the foundation of Blanchette's home, replacing the original log building. Today, it is the oldest existing

structure in St. Charles. Archaeologists continue to excavate this location, and artifacts dating to 1650 have been recovered, including Native American tools, pieces of dolls, guns and buttons—the kind of things that would be intentionally or inadvertently disposed of behind a trading post. Personal items, well-used tools and other things that traditionally attract and maintain a ghostly population continue to be unearthed.

The first church, built in 1791, was dedicated to San Carlos Borromeo, and the town became known as *San Carlos del Misuri* (St. Charles of the Missouri). Daniel Boone and his family were the first American-born Europeans to settle in the region, and the Spanish lieutenant governor, Carlos de Hault de Lassus, appointed him commandant of the Femme Osage District. Boone served in that post until 1804. At that time, the name of the town, San Carlos, was anglicized to become St. Charles.

The stretch of river at St. Charles is known to be a "power place." Power places are often created when people live in one location for a very long time. People have been living on the banks of this river for at least three thousand years before western settlers arrived, and by some accounts, perhaps even longer. A short distance east, perhaps two days overland, is the mound

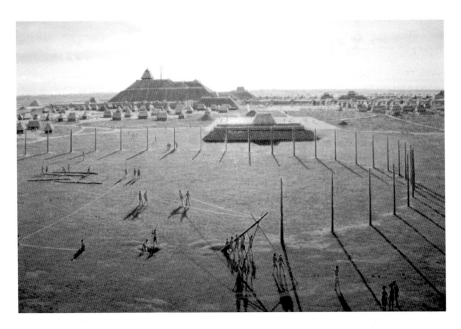

The Cahokia settlement as it appeared about 1100 CE. *Courtesy of Cahokia Mounds State Historic Site, painting by L.K. Townsend.*

settlement at Cahokia. In its day, this was the largest settlement of Native Americans on the continent. The fate of this prehistoric people is unknown, but the city thrived until about 1200 CE. By 1400, the site was abandoned, and the reasons for the civilization's decline continue to be the subject of many archaeological debates.

In 1821, Missouri was granted statehood. Politicians decided to build a "City of Jefferson" in the center of the state, overlooking the Missouri River. This land was undeveloped, so a temporary capital was needed. St. Charles housed the temporary state capitol until 1826. Free meeting space for the legislature was located in rooms above Peck's hardware store. This site has been restored and today is one of the smallest state parks in Missouri.

Jean Baptiste Pointe du Sable, a Haitian of African and French descent, built the first trading post (later to form the core of modern-day Chicago) on the Chicago River in the 1770s. He moved to St. Charles in 1813 and died here in 1818. He was buried in an unmarked grave at St. Borromeo Cemetery near Main Street. In 1968, the city erected a granite marker in the current Borromeo Cemetery, but the grave is reportedly empty.

When you sit on the banks of the Missouri River, it does not take much of an imagination to see, feel and perhaps even smell the ghosts lingering here. Distant conversations from nearby Main Street could easily be mixed with spectral voices hundreds of years old. The slow-moving water still suggests wakes left by canoes, flatboats or even steamboats. Faint wood smoke from modern restaurants drifts on the light breeze, odors unchanged from food prepared in 1750.

St. Charles is the second-oldest city in Missouri and one of the oldest cities in the United States. For most of its history, it could have walked out of any bad Western movie. There have been shootings in the street, prostitution, hangings and even a few lynchings. Thousands of people were born here, and died here, living very mundane lives. However, these are not the people who tend to leave ghosts. The scoundrels, the criminals and the victims of traumatic events—these are the ones who cannot, or will not, rest. Here are some of their stories.

HAUNTED TIMELINE

Bold font indicates events covered in this book.

1673 The first Europeans, Father Jacques Marquette and Louis Joliet, set foot on land that would later become Missouri.

1682 Explorer Sieur de La Salle, Robert Cavalier, travels the Mississippi River, claiming the valley for France. He named the region Louisiana in honor of King Louis XIV.

1699 Cahokia is founded. It is the earliest French settlement still in existence.

1700 Jesuit missionaries establish the first white settlement, the Mission of St. Francis Xavier, near the site where St. Louis would eventually be built.

1703 Kaskaskia settlement is established.

1750 St. Genevieve is established as a trading post, the first permanent European settlement in Missouri.

1762 Spain gains control of the Louisiana Territory in the Treaty of Fontainebleau.

1764 The city of St. Louis is founded by Pierre Laclède Liguest and René Auguste Chouteau.

1769 **Louis Blanchette establishes a trading post. It is called Les Petites Cotes.**
The first gristmill is built on the site of what is now the Woolen Mill Building.

1770 Daniel Boone builds a log cabin in Saint Charles County.

1791 Les Petites Cotes becomes San Carlos to honor Charles IV of Spain with the name of his patron saint, Bishop Carlos Borromeo.
The first church in Les Petite Cotes was dedicated to San Carlos Borromeo. The settlement became known as *San Carlos del Misuri*.

1793 Louis Blanchette dies.

1796 Daniel Morgan Boone moves to Missouri and builds a cabin at Femme Osage Creek.

1797 The population of the village of St. Charles consists of eighty families.

1802 **The Millington brothers set up an operation for the manufacture of castor oil.**

1803 The United States purchases 828,800 square miles of land from France. This transaction, known as the Louisiana Purchase, doubles the size of the United States.

1804 **The Lewis and Clark Expedition starts out from St. Louis.**
Land is transferred from France to the United States.
The Spanish name of San Carlos is anglicized to St. Charles.

1809 St. Charles is incorporated as a city.

1811 The New Madrid earthquake occurs, the worst earthquake in U.S. history. For several days, parts of the Mississippi River ran backward.

1812 A portion of the Territory of Louisiana becomes the Territory of Missouri. The first general assembly of the Territory of Missouri meets, and the five original counties—Cape Girardeau, New Madrid, St. Charles, St. Louis and Ste. Genevieve—are founded.

1818 The Academy of the Sacred Heart is established in St. Charles by Philippine Duchesne.
Jean Baptiste Pointe du Sable (the founder of Chicago) dies in St. Charles and is buried in the Borromeo Church cemetery.

1820 Daniel Boone dies at the age of eighty-six.

1821 President James Monroe admits Missouri as the twenty-fourth state. The state capitol is temporarily located in St. Charles.
William Eckert buys the block at 515 South Main and constructs the first part of what would become known as Eckert's Tavern.

1822 The Lady in White dies.

1827 Lindenwood College is founded by Mary Sibley and Major George S. Sibley. A log cabin is erected, and the Lindenwood School for Girls opens its doors.

1832 A cholera epidemic hits St. Charles.

1835 Dr. Millington makes the last shipment of castor oil from his factory in St. Charles. The factory closes the same year.

1836 The first part of the building that will become the Newbill-McElhiney House is constructed.

1837 **Elijah P. Lovejoy visits St. Charles to preach a sermon against slavery. A mob forces Lovejoy and his family to leave St. Charles the next morning. He would be murdered a short time later in Alton, Illinois.**

1849 St. Charles is incorporated as the City of St. Charles. **A second cholera epidemic strikes. In St. Louis alone, over four thousand people die.**

1850 **Old Doc Carr invents the corncob pipe.**

1851 The St. Charles and Western Plank Road Company is established. Its purpose is to build a toll road of wooden planks along Boone's Lick Road to the western part of the county. **The Woolen Mill is constructed on the site of the old gristmill.**

1853 **The St. Charles Borromeo Cemetery is moved to its current location on Randolph Street.**

1858 **Dr. McElhiney expands the house at 625 Main and adds a second floor.**

1861 The St. Charles Company, a military unit comprising fifty Union sympathizers, is formed. The Woolen Mill building is seized by the Union army to be used as a hospital and prison.

1863 **Francis Martin builds a lavish house at 837 First Capitol Drive.**

1865 Slavery is abolished in the United States. Missouri is the first state to formally free its slaves.

1866 **The Woolens Mill reopens after the Civil War.**

1867 **The Mother-in-Law House, the first double house (duplex) in the Midwest, is constructed by Francis X. Kremer.**

1870 **The tombstone maker's building at 337 South Main is constructed by Joseph May, a stonecutter.**

1871 The first railroad bridge to span the Missouri River is opened to traffic in May. It is now the Wabash Railroad Bridge.

1876 A tornado strikes St. Charles on February 27. Four persons are killed and over 150 buildings are damaged or destroyed, including the county courthouse, the jail and the concert hall.

1904 The World's Fair opens in St. Louis.
The first highway bridge to St. Charles opens, providing a route to the World's Fair.
Streetcar service becomes available in St. Charles.

1909 **The Goldenrod showboat is launched.**

1917 World War I begins.

1920 **The tragedy of the Miller's daughter occurs.**

1922 **The Woolen Mill reopens to produce tomato soup and catsup.**

1929 The stock market crashes and the Great Depression begins.
Streetcar service ends in St. Charles.

1939 World War II begins.

1940 The showboat era ends.

1981 **Several bodies are unearthed near the French Armory near Main Street.**

1984 **Miss Aimee M.L. Becker dies at age ninety-four.**

1992 Missouri voters approve riverboat gambling on the Mississippi and Missouri Rivers.

1993 The Great Flood of 1993 devastates parts of Missouri and the Midwest.

2004 **The reproduction of the original Borromeo Church is completed.**

2009 **The Goldenrod showboat is allegedly destroyed.**

THE LAST CIVILIZED STOP

St. Charles is a small town on the north bank of the Missouri, about twenty-one miles from its confluence with the Mississippi. It is situated in a narrow plain, sufficiently high to protect it from the annual risings of the river in the month of June, and at the foot of a range of small hills, which have occasioned its being called Petite Cote, a name by which it is more known to the French than by that of St. Charles.
—unabridged journal of Meriwether Lewis, 1814 edition

On May 14, 1804, William Clark and the Corps of Discovery left Camp River Dubois. They met Meriwether Lewis in St. Charles on May 16. The expedition intended to chart the course of the Missouri and Columbia Rivers westward to the Pacific Ocean. The Lewis and Clark Expedition is well known, but at the same time, many of the details are overlooked. It was probably the most successful and well-documented major expedition in modern history. The group left St. Charles on May 20, 1804. It was the last established town the men would visit for two years and 132 days.

The party consisted of forty men, three boats and a number of dogs. The only dog mentioned in the journals by name is Seaman, a Newfoundland, but some accounts claim that there were at least four other large dogs on the roster. While preparing for the expedition, Lewis visited a group of scientists in Philadelphia for instruction in the natural sciences, astronomical navigation and field medicine. It is believed that during this period Lewis

purchased Seaman, his "dogg of the Newfoundland breed," to accompany the corps on the expedition to the Pacific. He paid twenty dollars for the animal, quite a large sum at the time. The dogs are not listed on the roster of the party that embarked from the staging area at Camp Dubois. The only documentary clue we have is an existing scrap of an interleaf page preceding the first entry in Sergeant Charles Floyd's tattered longhand journal. Dated May 14, 1804, the note states cryptically, "[O]ur dogs."

We can easily imagine the dogs riding in the boats or trotting along the shore hunting with the men even though the journals do not record the dogs' daily activities. Captain Lewis first mentioned his dog in a journal entry on September 11, 1803, before the meeting at St. Charles:

> *I made my dog take as many* [squirrels] *each day as I had occasion for. They were fat and I thought them when fried a pleasant food. Many of these squirrels were black. They swim very light on the water and make pretty good speed. My dog was of the Newfoundland breed, very active, strong and docile. He would take the squirrels in the water, kill them, and swimming bring them in his mouth to the boat.*

The dogs next appear in Captain Clark's journal entry dated August 25, 1804:

> *Capt Lewis & my Self Concluded to go and See the Mound which was viewed with Such turrow* [terror] *by all the different Nations in this quarter…which the Indians Call Mountain of little people or Spirits…at six miles our Dogs were So Heeted & fatigued we was obliged Send them back to the Creek.*

The location of the original St. Charles campsite is well known and well marked, located in what is now Frontier Park. There is a marker at 800 South Main, the "closest point that would be convenient." In other words, this marker is in the wrong place. According to a newspaper article from 1964, "while the actual location was McNair's Landing, a plaque at the river site would go unnoticed by the general public and it was decided to use the Main Street Location."

Today, a simple metal sign marks the actual location.

In the center of Frontier Park, you will find a statue of Lewis, Clark and Seaman. The names—and breeds—of the other dogs on the expedition are

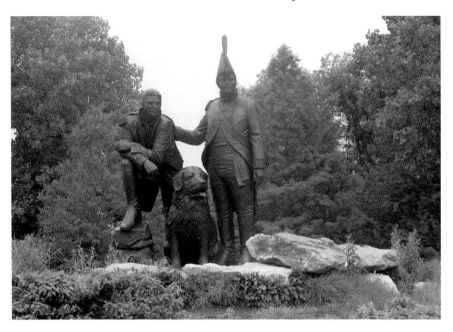

Lewis and Clark and their dog, Seaman. *Photo by author.*

not known. Reportedly, two of the dogs died while they were here, and they were buried somewhere in the area. The actual cause of death is not known, but some believe the Native Americans, having never seen animals of this type, thought they were food animals. For that matter, Lewis, Seaman's master, wrote that he liked the taste of dog meat when it was served to the corps. Clark said that he would not eat dog meat.

A Newfoundland can be immense. It is not unusual for a dog of this breed to run more than 150 pounds. They love to swim—it is almost impossible to keep them out of the water—and their front paws are actually webbed. They have a thick, rough coat, and unfortunately, when they get wet, they stink for days.

There are many stories about animals returning from the grave. The experience can be auditory, perhaps hearing the animal bark or howl or mew. In some cases an odor is left behind. Many people have had experiences with cherished family pets returning for a final visit or perhaps to say goodbye. The departed animal may brush against a leg or lick an outstretched hand. Sometimes there is an actual visual apparition—if nothing else, an elusive but familiar flicker at the edge of vision.

Blanchette House as it appears today. *Photo by author.*

At the south end of Main Street, the "oldest" part of St. Charles, a number of people have seen two big dogs moving down the middle of the street. They are described as big, with rough black coats and no legs. It is possible these people are seeing the spirits of the two lost dogs walking on the original street, which is about twenty inches below the current street. The animals are first seen near the banks of Blanchette Creek; they move down the road about fifty feet and finally fade away near the Blanchette Trading Post building. They have been seen by a number of people, usually in late spring, in April or May.

Unfortunately, journals and archives do not keep detailed birth, death and marriage records about dogs, and in that light, it is impossible to find any additional documentation for these spirits. However, these simple creek-side sightings are not the only record. Managers of a nearby restaurant maintain that on occasion, late at night, they will smell "wet dog" and hear what sounds like two big dogs playing or fighting in the patio area. Maybe the ghost dogs are competing for a scrap of food left behind by a patron. Sometimes one of the serving tables will be "bumped," and on one occasion, a table was actually knocked over during these auditory displays.

A week before Halloween 2009, a woman came out of the bar, paused on the sidewalk and exclaimed loudly, "Hey! Who didn't take a shower?" She stumbled out to the middle of the street, stopped again and said, "I smell wet dog!" Here is the frightening part of this story: she managed to unlock her car, get in and drive away.

No one is certain what happened to Seaman and the other dogs, but an interesting clue has been discovered in a book published by educator Timothy Alden in 1814. Alden writes about a visit to a museum in Alexandria, Virginia. At the museum, he viewed a dog collar with an inscription that read: "The greatest traveller of my species. My name is SEAMAN, the dog of captain Meriwether Lewis, whom I accompanied to the Pacifick ocean through the interior of the continent of North America."

Alden continued:

> *The foregoing was copied from the collar, in the Alexandria museum, which the late Gov. Lewis's dog wore after his return from the western coast of America. The fidelity and attachment of this animal were remarkable. After the melancholy exit of Governor Lewis, his dog would not depart for a moment from his lifeless remains; and when they were deposited in the earth no gentle means could draw him from the spot of interment. He refused to take every kind of food, which was offered him, and actually pined away and died with grief upon his master's grave!*

It is known William Clark donated some items to a museum in Alexandria in 1812. However, in 1871 a fire destroyed most of the museum and its contents. We are left to wonder exactly what happened to Seaman and the other dogs that traveled with the corps. It is easy to imagine a large ghostly dog sitting on the grave of William Clark, howling in abject grief.

THE TRAGEDY OF THE MILLER'S DAUGHTER

The building at 912 South Main is currently called Millstream Restaurant, but up until recently it was known as The Miller's Daughter. It was built by a miller, and he lived here with his daughter until about 1920. We do not know the daughter's name, but everyone calls her Molly. The family was religious and anti-alcohol. Ironically, for the last twenty-five years this building has been a bar.

In life, Molly was not happy. Her mother died giving birth to her, and soon childhood infections destroyed Molly's hearing. She never did learn to talk well, and her disability isolated her from everybody and everything. She lived alone in a silent world. There were no special schools available, and many of the people in town treated her as if she were tainted or even infectious. Some said she was cursed. Her only companion was a tiny black cat named Louie. Her cat added to the superstitious fear of the people in town.

According to stories, when Molly was about fourteen years old, her cat fell from the slippery rocks above Blanchette Creek and was lost. Molly could not be consoled, and a few days later she committed suicide. One night, she put on her nightgown and waited until everything was quiet. After her father was asleep, she hanged herself down the dumbwaiter shaft in the corner of the kitchen. The town was shocked but did not seem to grieve. Some even said "good riddance."

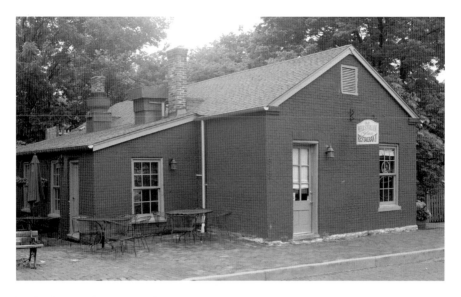

Molly's home as it appears today. *Photo by author.*

Her father was devastated—first his wife and then his daughter. He hung on for a short time but finally sold the building and moved on. No one knows where he went.

The building was vacant until the current owner moved in and opened a bar in the lower level. For many years, it operated as a quiet neighborhood watering hole, the kind of place loved by locals but not trendy enough for tourists. There was a pleasant outdoor courtyard on the banks of the creek with restful shade trees in the summer and fire pits with aromatic flames in the cooler months.

Almost as soon as the new business opened, strange things began to happen.

Most of the time, the bar was not very busy. Regular customers visited to unwind after a long workday. Others came to indulge in pleasant conversation or to meet with friends. Of course, it was a popular place to have a few drinks and watch the game on the television above the bar. Business might be slow, but it was good. There was a wide selection of beers and an extensive collection of collectable beer steins.

At first, it was little things. Late at night, patrons would see the faint outline of a young girl in an old-fashioned nightdress suspended in the corner above the bar. Others would hear a crash and a fall but would not see anything.

In the service area, there is a closet used to store cleaning equipment. When the bar gets a bit rowdy, the bartenders will often joke, "You guys better settle down or Molly is going to get upset." Occasionally, on nights like these, the door of the cleaning closet will be blocked—from the inside. A mop or a broom might cross the opening. Sometimes a big bucket of cleaning chemicals will be pushed up against the door. Some people believe that Molly is still hiding in the small room, trying to keep the energy of the activity outside.

About 1950, Molly's bedroom was divided and converted into restrooms. A second door was added for men, but the existing door was reused for women. In life, Molly had no friends, and the bedroom in the lower level of the substantial brick building became her sanctuary. She could not hear the noise, but she was sensitive to the treatment she received. It was a private space just for Molly and her cat.

Several times in the last few years, when someone goes into the women's restroom, the door will slam shut and the lights will go out. Naturally, the person trapped inside pounds on the door and tries to get help, but no one seems to hear. It is almost as if the sound will not pass through the door. One cannot help but be reminded of the silence that Molly endured. After a few minutes, the door gently releases, and the lights come back on. Everything is back to normal. Management has not ignored these incidents; the door has been checked and even replaced, but it does not seem to matter. Perhaps, on occasion, Molly just wants a bit of privacy.

Outside, a courtyard runs along the banks of Blanchette Creek. The creek edge is worn and flaky, but a decorative wooden fence keeps patrons safely away from the hazardous edge. It is usually quiet, and many people will sit in the comfortable chairs to enjoy a pleasant summer drink. However, more than once, the tranquility has been violated as a piece of the weathered bank breaks away and falls into the shallow but swift creek below. Some people even report hearing what could be the anguished wail of a cat as the stones fall into the water. At least twice, people have made their way down to the creek bed, convinced that a helpless animal needs rescue. Nothing has ever been found—no displaced stones, no helpless cat, nothing.

For more than twenty years, Millstream has been a quiet little bar. But in 2004, it expanded the main level and became a typically active sports bar. There were more customers, more energy and much more activity in the building. Finally, on a busy night in the middle of August, there was a fire.

Blanchette Creek. *Photo by author.*

The fire started small, and it was not noticed immediately. But when smoke finally filled the room, it was more than a fire extinguisher could handle. Emergency services were called and no one was hurt, but before the bar was completely cleared, the loyal customers formed a line and passed all the collectable mugs, hand-to-hand, outside to safety.

No one has ever figured out what caused the fire. It could have been sparks from the smoker, but the smoker was not in use that day. It could have been electrical, but there was no electrical equipment in the area where the fire started. Some say "oily rags" in the storage closet, but the cleanup crew was always careful. Anything hazardous was always handled correctly. The bar was closed for a long time while the investigation was conducted.

Finally, the insurance company settled, without a firm conclusion. The fire occurred and the building was damaged, but no one could find the underlying cause. We may never know what caused the fire, but many people think that one night Molly just lost her temper and burned the place down.

The Millstream Restaurant is open today. The lower level is still a neighborhood bar, but the upstairs is a quiet, classy restaurant. The downstairs bar still gets rowdy sometimes, and on occasion someone will see the ghostly figure of Molly hanging in the corner. Once or twice a year,

The patio next to Molly's home. The ghost dogs sometimes are found in this area. *Photo by author.*

management will not be able to get in the storage closet, and when the restroom door jams, everyone in the bar knows about it.

And once in a while, on a quiet summer afternoon, someone will hear a cat fall into the creek. If you listen carefully, you may also hear a young girl crying inconsolably.

THE OLD WOOLEN MILL

The historical markers on the corner of South Main Street and Boone's Lick Road can be a bit confusing. A bronze plaque seems to date the building to 1769 and describes it as a gristmill. The sign seems to indicate that the building is the oldest building in St. Charles, but in fact, the marker simply records the site of the original gristmill, built by Louis Blanchette, that has long since been destroyed. The current building only dates to 1851 and was known as the Woolen Mill. For many years, it supplied woolen blankets and other woolen goods to the United States government for military use. It employed more than one hundred people.

According to a newspaper article dated May 17, 1861, "a regiment of Union Troops came to St. Charles from St Louis, taking full possession of the town. All men who did not take the oath of allegiance were herded and marched to the military prison. They took every gun and rifle they could find and the local militia was renamed St. Charles Cadet Co. These were dark and unhappy days here." In 1863, the Union government seized a number of buildings in St. Charles, including the Woolen Mill. For the rest of the Civil War, the location was a hospital and prison.

After the war and until 1872, the mill was once again operated by the Woolen Mills Company of St. Charles, which now specialized in the manufacturing of stockings. Apparently, after the company's bad experiences during the war, it avoided military contracts and produced only consumer products. The company was in operation until about 1881,

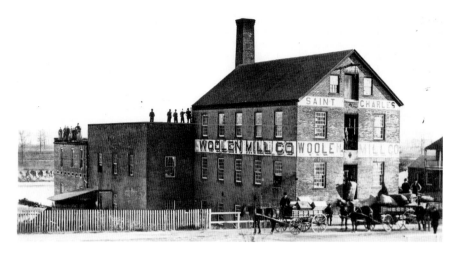

The Old Woolen Mill. *Photo courtesy of St. Charles Historical Society.*

when competition put it out of business. The building was vacant for several years.

Tradition says that old "Doc" Carr of St. Charles invented the corncob pipe. We know he lived at 520 South Main in 1850 and was an editor of the *Clarion News* "in his younger days." He was described as an "Indian fighter, bagger man and hunter."

It seems Old Doc liked to whittle. He smoked a pipe, and he enjoyed a "sweet smoke." Supposedly, one night he dreamed about a pipe made from a corncob. He spent hours whittling and finally perfected a fine but inexpensive pipe. In his old age, he whittled away and made a bit of money selling his popular pipes for five cents each. He sold every pipe he made.

In 1892, Doc opened a factory in the Woolen Mill building: the Missouri Corncob Pipe Factory. Taking advantage of Doc's success, there were at least two other small corncob pipe factories in St. Charles, one at Second and Clark Streets and another listed at Second and Jefferson. Farmers sold suitable corncobs to the factories for cash, and records show that in the first year, at Doc's facility alone, 2,256,929, pipes were made. Forty-eight men were employed, working six days a week. Records show that these pipes were shipped to buyers from Maine to the Pacific Coast and from the Gulf to the Great Lakes. The pipes usually sold for ten cents each and were advertised to "make a superior and delightful sweet smoke." By 1897, the demand was

so great that the capacity was increased to 125 gross per day. This lowly pipe was often called the Missouri meerschaum.

St. Charles gained a reputation for corncob pipes, but soon there was competition. A factory opened in Washington, Missouri, that produced a better pipe. A lawsuit was filed—it seems that Doc Carr had never applied for a patent—and as a result, the Missouri Corncob Pipe Factory was forced to close. Once again, at least officially, the building was vacant.

Records for the next few years are vague. Most accounts describe the building as a "residence," but most likely it was simply used by squatters, vagrants and the homeless. Stories of domestic violence, assault and prostitution appear in various articles, journals and personal letters. The building was not maintained but remained structurally sound. Apparently, the town simply ignored the site and hoped the problems and the people living there would simply go away.

The building was finally sold in 1922, and Sarah Frasier used the building to produce canned tomato products. The company did well for several years and employed more than 125 people. Frasier's tomato soup and tomato sauce became famous and were sold all over the country. In addition, Frasier was a Christian Science reader and was instrumental in building the first Christian Science Church in St. Charles. She spent more and more time with her religious interests, and the company closed about 1949.

The building was then remodeled and occupied by Stemco Manufacturing for a short time. The factory produced specialized truck equipment, bearings, seals and hubcaps. Stemco moved to Texas in 1958, and again the building was empty. It is almost as if the building could not decide what it wanted to be.

During the 1960s, St. Charles's Main Street was in decline, and many buildings were empty. The Woolen Mill building was neglected and was probably used by squatters once again. At that time, the St. Charles Historical Preservation Society wrote a series of articles and editorials about the attractive and formidable building.

According to newspaper accounts, "The building is sound; the handmade brick walls beautifully preserved; the walnut beams are as strong as the day it was put up. We cannot continue to neglect this building."

Their campaign had an impact. Sometime around 1970, the building changed—again. A restaurant and brewery opened on the site. If you are not confused yet, you should be. The building is a chameleon, and with

every change, more information—and misinformation—is added to the accounts. Today, it remains a successful restaurant and brewery. Thousands of people pass through the doors each year. The markers on the building are a bit confusing, the building's history is complex and confusing and the stories about the resident ghosts are unconventional, complex and confusing. Each time the building changes, more stories come to light. The location seems to retain a bit of the energy from each phase, and a number of ghostly stories are told.

In an active area such as Main Street, there is often what is called a generic or a repeating ghost. For example, in Colorado, many stories are told of a mysterious man in buckskins or an indistinct figure in Native American costume. In Chicago, everyone seems to have a gangster living in their basement. The repeating ghost in St. Charles seems to be a male and a female ghost. In some cases, it is a Victorian couple. At the winery, it is a French couple. At least three locations, including the Woolen Mill, report a form of these ghosts.

At the mill, they are just a simple couple, dressed in common clothes. They are seen wandering all over the building, on every floor and even sometimes in midair, "walking on floors that were removed years ago." They are sometimes described as victims of the Great Depression or perhaps lovers looking for a private place. Frankly, this story has little credibility. There is no corroborating evidence, and if you ask the employees about any ghosts here, this is the story they will share. There are no firsthand accounts, and the story seems to get bigger and bigger as time passes. More details are added as new bartenders are hired, and like many urban legends, the story has acquired a life of its own. Ghosts are popular these days, and according to residents up and down Main Street, every single building is haunted. We know this is not the case. It's likely that the ghost couple provides a good explanation for strange sounds and unexpected events in the old building late at night—spooky, but not necessarily ghostly.

However, in addition to the generic man and woman, some longtime employees have reported seeing a man in a Civil War uniform in the back service area. In contrast, this manifestation does have significant credibility. The stories come from independent sources and from witnesses who are not familiar with the history of the building.

According to nearby residents, a Ouija board revealed that the ghost's name is Albert, and he was a Confederate officer who had been imprisoned

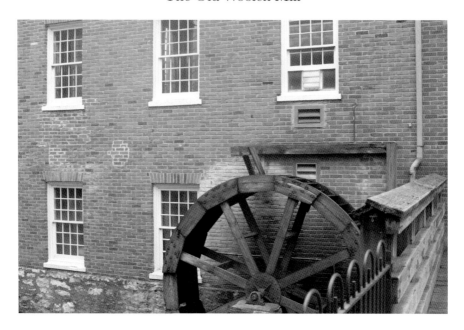

The Woolen Mill as it appears today. *Photo by author.*

here by the Union army during the Civil War. During the séance, Albert also revealed that he "owned as many slaves as he could get his hands on."

Historically, the building was a Woolen Mill, a corncob pipe factory, a truck parts manufacturing facility, a tomato products factory and a "residence." The other functions and owners are more or less forgotten. When the building was a hospital and a prison, beyond any doubt, more than one person died here. In some cases, witnesses report a man in a gray uniform; others say it is blue.

Finally, on the grounds surrounding the building, images of Native Americans are seen. By some accounts, there were several battles near the creek, and bodies may have fallen in the creek or, according to some stories, were thrown in the creek and were not buried. An early historical account tells of a man named John Johnson. It says, "He never let an opportunity pass to slay a red man." On one occasion, he saw an Indian disguised as a buffalo, wearing a hide with the horns attached. The disguise was so transparent that he was not fooled at all. Making a wide circuit, Johnson came in behind the man and sent him "speeding on his way to the happy hunting ground." For more than five years after the murder, Johnson dressed in the dead man's

garb, never slept in a house and continued his personal, irrational campaign. He was known to often "sleep with nothing but the heavens for a shelter in the area surrounding the early woolen mill." By some reports, he murdered perhaps twenty more members of the Algonquin and Osage tribes.

The stories coming from the Old Woolen Mill continue to change and multiply. A local paranormal group has been investigating the "man in uniform," and there may be a solid basis for this story. A recent overnight investigation yielded several interesting photographs and more than one unexplainable energy reading (EMF). The ghost couple continues to be reported, mostly as stories from the servers, bartenders and slightly inebriated customers.

Still, it cannot be denied, the building is interesting, and the research will continue. The tragedy of the Civil War, the violence of the murders and the sadness of homeless people—any or all of these elements could account for the activity that is reported. The owners, employees and customers continue to keep watch.

THE LAST SHOWBOAT

THE *GOLDENROD*

When the showboat rounded the bend you could hear the calliope playing, and it stirred the blood. It was the boat's ballyhoo, advertisement and come on, suggestive of amusement to come. It got the population in the mood to be at the show... There was hardly a spot in the little town where I lived that the sound of the calliope didn't reach. After all these years I can recall in my "mind's ear" the thrilling sound.
—eyewitness account of the arrival of the Goldenrod

Showboats, also called floating theatres, floating operas or boat shows, were theatres on boats bringing entertainment to small towns of the midwestern and southern states. The showboats flourished during two great eras. The first began in the 1830s and ended with the outbreak of the Civil War. The second era began in the 1870s and continued into the 1940s.

The first showboats were family owned, serving isolated river towns. They were modest crafts of simple construction with seating for between one hundred and three hundred people. They did not carry passengers or transport goods, only culture and entertainment.

British-born actor William Chapman Sr. created the first showboat in Pittsburgh in 1831. It was named the *Floating Theatre*. The Chapman boat floated down the Ohio and Mississippi Rivers, tying up for one-night performances at river landings anywhere an audience could be found. He and his nine-person family served as the entire cast and crew. Admission to the show was sometimes accepted in the form of eggs, chickens or other

foodstuffs. Edna Ferber, in her book *Showboat*, published in 1926, described the excitement:

> *Now the crowd was drifting down to the landing as the showboat lights began to glow. Twilight was coming on. On the landing, up the riverbank, sauntering down the road, everybody came, the farm hands, the river folk, the curious, the idle, the amusement hungry. Snatches of song. Feet shuffling upon the wharf boards. A banjo twanging. The showboat had finally come to town.*

By all accounts, the *Goldenrod* was the largest and finest showboat ever to travel the inland waterways. It was launched in 1909 and is reported to be the last showboat ever built. Constructed by the Pope Dock Company of Parkersville, West Virginia, for W.R. Markel, it cost $75,000. It measured 200 feet long and 45 feet wide. On the outside, it was the least ornate of all the showboats. But on the inside, the *Goldenrod* was the envy of every other floating theatre. The auditorium was 162 feet long and was furnished with twenty-one red velour upholstered boxes on two levels. There were fourteen hundred seats on the main floor. It was modeled after the Majestic Theatre in Denver, Colorado, and boasted more than twenty-one hundred electric lights arranged in dramatic clusters. Full-length mirrors made the space appear to be larger, while gilt friezes, rich red draperies and bright plush carpets reinforced the illusion of opulence. The greatest showboat owner of the era, Markel was a colorful sort, a gambler-turned-entrepreneur. He financed the *Goldenrod* and two other boats, the *Grand Floating Palace* and the *Sunny South*, with his poker winnings.

The boat was originally named *Markel's New Showboat*, but on the advice of his sister, it was soon renamed *Goldenrod*. It was equipped with hot and cold running water, steam heating for the winter and a cooling system for the summer. The calliope served as a condenser and produced the vessel's drinking water. Electric energy was generated by the towboat's steam engine.

It is said that when Edna Ferber first saw the boat, she fell in love with it, and it inspired her to write her book, *Showboat*. It's more likely that Ferber's book is actually based on the time she spent traveling with the *James Adams Floating Theatre*. She later wrote, "Those four days [on the *James Adams Floating Theatre*] comprised the only show-boat experience I ever had."

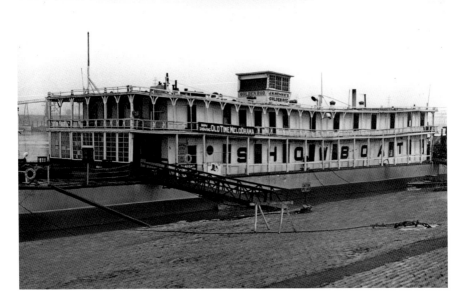

The *Goldenrod* showboat, circa 1910. *Photo courtesy of Missouri State Archives.*

In 1913, Markel lost the boat by foreclosure, and it was sold at auction for $11,000. It was purchased by Ralph Emerson, and in 1922, he sold it to Captain Bill Menke and his brother, Charles Menke. While managed by the Menke brothers, the *Goldenrod* enjoyed a number of productive seasons, including two summers, in 1930 and 1931, at Aspinwall, Pennsylvania. For more than fifteen years, the *Goldenrod* visited at least fifteen states each year. In a newspaper interview, Captain Bill Menke talked of the 1924 route.

> *We would go from Pittsburg to Fairmont on the Monongahalea, then down the Ohio to Cairo, Illinois and up the Illinois River. Returning to Cairo, we would go north as far as St. Paul, then down the Mississippi again and up the Missouri to St. Charles, Kansas City and Omaha. The last leg took us down the Missouri and Mississippi to New Orleans.*

In 1910, twenty-one showboats ran the river circuits. By 1928, this number had dwindled to eleven, and by 1938, only five remained. The Depression, automobiles and motion pictures all contributed to the decline. By the early 1940s, the days of the showboats were all but over.

In the summer of 1937, the *Goldenrod* went to St. Louis for repairs and remained moored at the Locust Street Landing. By 1950, it had been partially sunk and salvaged twice. Shows were still being staged, and for an admission fee of seventy-five cents, St. Louis playgoers could board the boat and "sass the actors" on stage.

On June 1, 1962, a fire caused by an electrical problem all but destroyed the superstructure of the auditorium and caused severe damage to the entire structure. However, the vessel refused to die. The *Goldenrod* was purchased by a group of St. Louis businessmen, who restored it to its original glory and beyond. Plush carpeting was laid in the auditorium, this time with cabaret seating, under a huge crystal chandelier. Many antique appointments were salvaged from old St. Louis mansions. Brass fixtures and rails were restored or replaced, as were the tin ceiling and elaborate woodwork. A cocktail lounge was added with a small bandstand. The upstairs staterooms were converted into a buffet dining room. When this $300,000 renovation was completed, the *Goldenrod* had its grand reopening in May 1965. In 1967, it was registered as a National Historic Landmark

From the early 1960s until about 1985, the National Ragtime Festival was staged aboard the *Goldenrod*, featuring many vintage jazz and ragtime bands. From 1975 to 1984, the *Goldenrod* was operated as a sister theatre to the Heritage Square Opera House in Golden, Colorado, presenting a unique style of melodrama and vaudeville.

In 1989, the boat was purchased by the City of St, Charles for $300,000 and moved to the historic Missouri River town. It was restored and renovated, costing the city about $3.5 million over the next twelve years. The dinner theatre continued to operate, but in 2001, the boat was again damaged when Missouri River levels ran low. The attraction was closed by the Coast Guard and deemed unsafe. The repair estimates were much higher than expected, and the city council decided to sell the boat in 2002. When no one offered to buy it, the council decided to give it away. The boat was moved to storage near the Poplar Street Bridge in downtown St. Louis, and finally, it was moved to Kampsville, Illinois.

Victoria's Secret

Ships are often haunted. Theatres are often haunted. Put them together, and paranormal activity is almost inevitable. The *Goldenrod* has enjoyed a long and colorful life. A ghost would be required to make its history complete. After the lights have been turned out and the guests have left, is the boat really silent and empty? Many former staff members and performers say no. They claim it is haunted by the ghost of a girl in a red dress.

She has been named Victoria, and she apparently has been around for many years, long before the boat came to St. Charles. Around the turn of the century, a widower worked on the *Goldenrod* and was raising his only daughter on board. Reportedly, Victoria was a vivacious, outgoing young woman. She was always backstage; she performed in a few small roles, but she wanted to be a star. She had a beautiful voice and, by most accounts, "a stunning figure." She and her father lived in the staterooms where the banquet room is now located.

One night, after an extremely successful performance in St. Louis, Victoria and her father had a terrible fight. There were several standing ovations, and Victoria basked in the success. She had played a minor role that evening and felt that her contribution was significant. She was tired of being a bit player. She was tired of being nothing more than an observer or understudy. She wanted to be a star, but her father said no. The widower, perhaps overprotective, would not discuss it, and Victoria stormed off the boat to sulk, walking alone on the dangerous St. Louis riverfront. She never returned.

A short time later, her body was found in the river, her long hair tangled around her throat and her dress ripped, exposing her pale skin. She had been brutally attacked and beaten. The crime was never solved. The widower's spirit was broken, and from that time on, he drank heavily, night after night, while floating down the river. He died a short time later—of heartbreak and regret.

Strange stories have been whispered amongst the *Goldenrod* employees ever since. Doors would slam as if in anger, items moved about and sometimes objects even levitated. Actors and staff members began to report seeing a mysterious, and angry, young woman in a red dress. Perhaps Victoria, who never realized her dreams of performing on the *Goldenrod* during her life, is producing live performances after her death. She does not seem to be malicious; she is just there roaming, at all hours.

While the *Goldenrod* was moored at St. Charles, the director of the Greater St. Charles Convention and Visitors Bureau told the following story:

> *I was on the boat about eleven at night, and I was there with the general manager, who also saw the ghost. We were closing the boat up, and we walked down the gangplank to the gate, and we were locking the gate up, and we both sort of looked up.*
>
> *We saw the figure of a woman in a red dress—at least it appeared to be red, or a dark dress—with long brown hair, peering out at us from the upper deck of the boat. It was a long dress where the shoulders were kind of puffed up. I'd say it looked like a Victorian type of dress or at least an early 1900s type of dress.*
>
> *We both said, "There is nobody else on this boat"; and she just looked at us and sort of turned and walked away. We were probably fifty yards away or so—it was clearly visible.*

In the late 1990s, the *Goldenrod* was moved from St. Charles and stored for a short time south of the gateway arch. The owner at that time said, "I have heard the stories but have never seen Victoria myself, but apparently she is still is angry and is still on board." He also reports that an electronic alarm was installed at that time. The alarm went off more than once but shut itself off before anyone arrived. On one occasion, the alarm went off, but when the police arrived, everything was quiet. However, during their investigation they discovered a message. Someone had written "Victoria" in the dust on one of the tables in the main lounge. No footprints were found, and nothing else was disturbed. No one had been in the area for a long time.

Victoria may not be the only ghost on the *Goldenrod*. During a performance of *Forever Plaid* in 1991, more than one performer reported a presence in the dressing rooms and in the wings on stage. Ironically, *Forever Plaid* is a story about a ghostly singing group. Servers at the dinner theatre sometimes insisted that someone—or something—was disturbing table settings before the patrons arrived. Other people report hearing doors slam in areas where no doors are located, and at least one employee reports being pushed by something that seemed to be rushing down a stairway toward the gangplank.

Today, the fate of the *Goldenrod* is unknown. It is believed to have been quietly destroyed and sold for scrap in 2009. The boat itself may now be nothing more than a ghost. The gaudy casinos currently located on the

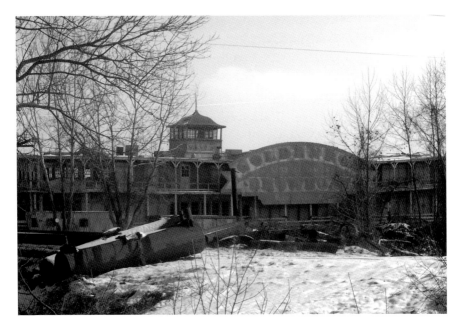

The *Goldenrod* showboat moored at Kampsville, Illinois. *Photo courtesy of Joe Virruso.*

riverbanks at St. Charles sometimes echo the opulence of the old riverboats, but there are no steam calliopes, and admission costs are slightly more than a few chickens. Fancy cars have replaced the carriages, but the food and the entertainment remain. The crowds still come from miles around to visit the St. Charles riverfront. Much has changed, and much remains the same.

Perhaps some new ghosts are being created.

THE LADY IN WHITE

I don't like this place. I think I will move before next month. Some of the houses are made from sod and have flowers and weeds growing out of the walls. Every time the river comes up some of them fall down. The town smells bad, the odor from the swamp is everywhere. The doctor says if I lived farther out, it would be healthier for me. He says I need to get away from the Cholera. I will sell everything. I will not have much to pack. I might even have enough money left to buy a mule.
—*from a letter written by Hiram Berry, dated September 11, 1822, and mailed from St. Charles, Missouri, to his family in St. Genevieve, Missouri*

In the 1800s, life was not easy in St. Charles. In 1804, the village was reported to have about 450 inhabitants living in "generally small and poorly constructed houses." One account, from the Lewis and Clark journals, goes on to say:

> *A great majority of the inhabitants are miserably pour* [sic], *illiterate and when at home excessively lazy, tho' they are polite, hospitable and by no means deficient in point of natural genious* [sic], *they live in a perfect state of harmony among each other; and plase* [sic] *as implicit confidence in the doctrines of their speritual* [sic] *pastor, the Roman Catholic priest, as they yeald* [sic] *passive obedience to the will of their temporal master the commandant.*

A small garden of vegetables is the usual extent of their cultivation, and this is commonly imposed on the old men and boys; the men in the vigor of life consider the cultivation of the earth a degrading occupation, and in order to gain the necessary subsistence for themselves and families, either undertake hunting voyages on their own account, or engaged themselves as hirelings to such persons as possess sufficient capital to extend their traffic to the natives of the interior parts of the country; on those voyages in either case, they are frequently absent from their families or homes the term of six twelve or eighteen months and always subjected to severe and incessant labour, exposed to the ferosity [sic] of the lawless savages, the vicissitudes of weather and climate, and dependant [sic] on chance or accident alone for food, raiment or relief in the event of malady.

These people are principally the decendants [sic] of the Canadian French, and it is not an inconsiderable proportian [sic] of them that can boast a small dash of the pure blood of the aboriginees [sic] of America.

Missouri was granted statehood in 1821, and by that time the population had grown to almost four thousand people. A number of higher-quality permanent buildings had been constructed, including the formidable Stone Row, the Capitol Buildings (Peck Brothers Hardware) and the Farmer's Tavern (Currently Dengler Tobacco). Before 1850, the Newbill-McElhiney House, the Old City Hall (also known as the Market House) and the Mother-in-Law House were built. St. Charles was off and running—an active and growing city.

Until about 1853, the Borromeo Cemetery was located right in the middle of town, running along Main Street from about 300–500 South Main and up the hill to what is now Third Street. How many people were buried here is not known, but it could have been three hundred or more. In 1850, it became inconvenient to have a necropolis in the middle of a living city, so the graveyard was moved to its current location on Randolph Street. Every effort was made to move all the bodies, but at times the records were incomplete.

The first church built in St. Charles was dedicated by Lieutenant Governor Manuel Perez and Father Jean Antoine LeDru on November 7, 1791. It was named after the Cardinal of Milan, Charles Borromeo. In the late eighteenth century, there were no public buildings. The church was the center of community life. Births and marriages were celebrated here.

After Mass, there were auctions, announcements, amusements, singing, dancing and games. Of course, services for the dead were also held here. It was a short distance from the church to the grave sites. Tradition says that Louis Blanchette was buried beneath the church floor in 1793, alongside his Pawnee wife, Angelique. She had died three months earlier. Reportedly, their bodies were moved to the new cemetery in 1894, but recently these graves were opened, and no remains were found.

In 1828, a second Borromeo Church was built at North Second and Decatur Streets. At that time, Father Vanquickenborne, a visiting Jesuit pastor, wrote:

> *The churches are in a deplorable condition, and threatened with ruin. For it is out of the question for these poor people to build in brick or stone, and their miserable structures cannot last more than twelve or fourteen years. They look like stables.*

The original church was essentially abandoned at that time.

In 2004, a group of volunteers began to rebuild the eighteenth-century vertical log Borromeo Church at the original site inside the old cemetery. This is the first time in two hundred years that a French-style vertical log building has been constructed in the area—and perhaps in all of North America. This architectural style is unique to the French, in the New World, in the seventeenth and eighteenth centuries. Although *poteaux-en-terre* (post-in-ground) buildings were once common in French villages in the Missouri/Mississippi River Valley, only four examples exist today. This current reproduction, like the original, was built using rot- and termite-resistant cedar logs; split cedar shake shingles; oak roofing timbers; hand-forged iron hinges and locks; and native limestone flooring. Today, on occasion, Mass is celebrated here, and in 2009 a wedding was held here—the first in almost two hundred years. The building can be found on the north half of Block 28, between Jefferson and Tompkins, on the west side of the street behind the shop at 401 South Main.

The main cemetery seems to have been located just uphill from the chapel, but the area immediately surrounding the church building was used as a potter's field. People who could not afford to be buried in the main cemetery were often laid to rest here. They were often buried without a name. If they had coffins at all, they would have been wooden coffins that have long since

disintegrated. About 1830, there was a report of a hunting party found in the woods; three unidentified men had frozen to death. After a time (they never were identified), all three bodies were unceremoniously tossed into a single grave. Other accounts talk of slaves, Native Americans and poor farmers, unable to afford a grave in the "proper" cemetery, simply being dumped in a hole and forgotten. Records were sloppy, and in some cases there were no records at all. One document shows payment to a group of Irish stoneworkers on their way to St. Louis looking for work. They were paid ten cents for each headstone they moved to the new location. Apparently, at least in this part of the cemetery, no effort was made to locate the bodies.

Beyond any doubt, there were bodies left behind here. It could be as few as ten or as many as thirty. After more than 150 years, it is impossible to make a body count without excavating the entire area. In 2008, investigators brought ground-penetrating sonar into the area. Unfortunately, the results were inconclusive. Human remains tend to have the same density as the surrounding ground. There are tantalizing indications of lost grave sites but no firm proof.

In 1981, a retaining wall was being installed behind the building known as the old Armory (or French Armory). During the excavations, the workers

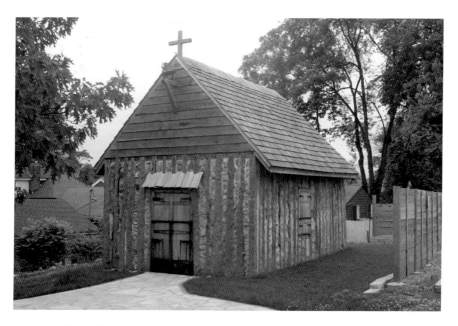

Reconstruction of Borromeo Church. *Photo by author.*

opened two graves. This discovery held the project up for almost two years while the remains were evaluated. There was concern that the remains might have been Native American, but eventually it was determined that the remains were probably slaves. Sadly, they were placed here and forgotten.

The bones were discovered by a local general contractor. When one of the workers accidentally dropped a level, the level clanged, prompting him to look a little closer.

"I saw these two bone ends sticking out," he said. Thinking they were animal bones, the crew dug deeper and saw a hip socket that looked human. At that point, they called the St. Charles police, who came out and took pictures. They also called a former county coroner, who was filling in for the county medical examiner.

The examiner identified the bones as human femur bones, and he also remembered that there had once been a Borromeo Church cemetery on South Main Street from stories written by Edna McElhiney Olson, an area historian.

According to Mrs. Olson and Borromeo burial records, the old cemetery contained the graves of early pioneer settlers, including St. Charles founder Louis Blanchette and his Native American wife, Angelique. The cemetery was dedicated on December 7, 1789, and the first Borromeo Church was dedicated on November 7, 1791.

The old cemetery and its graves were moved twice, first in 1831 to a cemetery at Fourth and Decatur Streets and again in 1854 to the present Borromeo Cemetery at West Randolph Street. But apparently some graves were missed, either by oversight or possibly because there were no interested surviving relatives. "I had no idea that a cemetery was there," one worker said. "It was a little spooky."

After digging the bones up, nobody really knew what to do with them, so St. Charles Borromeo Parish officials were called in. They suggested simply burying the bones again. It was done.

They do not expect to find any more bones, since all the excavating work is finished. But the location of the two graves was measured and recorded by the director of the St. Charles County Historical Society. "We knew there was a cemetery there, but we didn't know exactly where it was," he said. "Apparently it goes back under the alley. The bones were found close to the alley that runs between Main and Second Streets, near the corner of Main and Jackson Streets."

They are still there today.

THE TOMBSTONE MAKER'S HOME

One of the many interesting historical buildings on the grounds of the former graveyard is located at 337 South Main. It was built in 1870 by Joseph May, a stonecutter. In other words, he was a tombstone maker. There are dramatic Corinthian columns at the front of the building, and the entranceway sills are fine marble. Unlike the other buildings up and down Main Street, all of the gingerbread on this building is carved stone, not wood. One of the windowsills on the second floor is broken off. It is clearly made from stone. According to neighborhood traditions, the marble entranceway is made from tombstones that were spelled wrong or never picked up. More likely, Joseph simply had the material on hand and wanted to put an attractive entranceway on the building.

If that is not enough strangeness, the floor inside the building is slanted, from front to back, almost ten degrees. Joseph's workshop was in the back of the building, and when a marker was complete, he would simply slide it down the incline and out the front door for presentation and delivery. Inside the building it's like a crazy house— the walls and the floor don't match. Often people report a feeling of nausea or dizziness. Many people cannot stay in the building for very long, and it is actually easier to walk out of the building than in. When you are walking out, you are walking downhill. It is an unconventional building, and its history—a tombstone maker's workshop on the grounds of an old graveyard—is one of mysteries within a greater enigma.

A LETTER HOME

In 1822, Hiram Berry wrote a letter to his family in St. Genevieve, Missouri. Almost fifty years before Horace Greeley advised young men to "go west," Hiram moved into a rough and undeveloped western place. Life in the town was hard for everyone. People were born here and people died here. According to Hiram's letter, he was not happy or healthy. He was probably a victim of the cholera epidemic.

Hiram was not an educated man, but he wrote a sensitive and eloquent letter. He talked of conditions in St. Charles. He said that the town smelled bad because of the nearby swamp. He mentioned the cholera, and at least

Hiram Berry's letter, dated 1822. *Author's collection.*

one account talked of a mass grave, containing perhaps forty bodies. The mass grave, if it existed, was in the swamp and has certainly been destroyed by the repeated flooding.

Toward the end of Hiram's letter, his tone changed. He talked of a woman that "lives down the March." She was twenty-three years old, had been married a little more than a year and was pregnant. He spoke of her affectionately and described the birth of a "beautiful boy baby."

> *She did not have a hard time but fever set in and the evening before she died she got delirious. She did not know any one for 24 hours before she died. She was so proud of her baby she never thought she would die. Never said anything but she wanted the priest. He came the day she got delirious.*

There was a large funeral. People came in carriages from miles around. Hiram observed, "It was as if she were famous or a very big man."

Like Hiram, the couple was very poor. Beyond a doubt, she was laid to rest in the potter's field surrounding the church. She was buried in her wedding dress, the only nice dress she owned. He described her lying in her rude coffin, her head turned slightly to one side, a smile on her lips, wearing her white dress trimmed with cream lace. In very simple words, Hiram made it clear: he was very fond of this woman.

Her name, the name of her son and the location of her grave are lost. But turmoil, sickness and perhaps guilt are factors that often leave a restless spirit. Over the years, a number of people report that while standing on the sidewalk at what was once the entrance to the cemetery, looking up the hill, they see a woman in a long white dress standing quietly, perhaps praying, in front of the reconstructed church. They approach. She looks up, looks at them and then fades away or glides out of sight behind the building.

This apparition, the Lady in White, is the best documented and perhaps the most frequently glimpsed ghostly visitor in the area. She is also perhaps the most romantic. She is always seen right around sunset and fades away with the fading daylight. Some say it looks as if she is holding a glass of wine. Others remark that she smiles but still seems so sad.

Hiram closed his letter by saying he was "in trouble" and must "get out of town" before it got worse. He did not mention the type of trouble he was experiencing, but reading between the lines it is possible to guess. Hiram was leaving town because he, not the woman's husband, was the father of the child. We can add a bit more sorrow, heartbreak, romance and sadness to the story—more factors that often leave a restless spirit.

Even at that time, St. Charles was producing fine wine. Visitors sometimes spoke of the "fine local beers," but "the excellent local wines" were quite well known and quite popular. We can imagine Hiram pouring two glasses of wine—one for himself and one for the woman he would never see again. Perhaps in a private ritual, he finished his glass and poured the other on her grave before moving on into history.

Nothing more is known about Hiram. As far as we know, this was the last letter he wrote. It seems that he did leave town. Did he die somewhere in the wilderness? Did the husband or the authorities catch up with him? Perhaps somewhere along the trail there is another ghost—a melancholy man standing quietly, a glass of wine in his hand, looking for a pretty lady in a long white dress.

THE REPENTANT SHERRIFF

Until about 1906, the gallows were located near Main Street, just behind the courthouse. According to reports, the last public execution in St. Charles took place in 1904. The information about the execution is incomplete, but it is possible that the last two men executed here may not have been guilty of the crimes that resulted in their hanging. These men were not nice people, nor were they popular people, but evidence suggests that they were finally caught at something, and the law decided to take care of the problem once and for all.

According to accounts, Charles May and John Taylor were local troublemakers. Every time they came into town, there was trouble, and they spent more than one night "cooling off" in the local jail following a bar fight or some other drunken brawl. Charley and Johnny were quick to use their fists and often quick to use a knife. They were ready to take credit for all the violence in town and may have even been responsible for most of it.

On a cold January night in 1902, there was a fire in a small farmhouse just west of St. Charles. In that fire, a young couple and their eight-month-old child died. During the investigation, it was found that the man and his wife had been shot and the child was left to die in her bed. Charley and Johnny were in town that night, and some say they talked of that smart-mouthed woman never sassing them again. They may or may not have been responsible, but in any case, they were convicted of the murders.

In the early twentieth century, St. Charles was more than a small town, but it still retained many characteristics of a frontier settlement. There were new people, new buildings and new problems. On occasion, justice was swift. On April 17, 1904, the men were put to death. Many people attended the event. By some accounts, there were food vendors, pony rides and even a few people fighting over the best viewing spots. A century earlier, this type of behavior was not rare. A good hanging was the only entertainment for miles around. But this was 1904; the World's Fair was going on just across the river.

At the site of the gallows, people report a heaviness in the air, a spiritual pressure and sometimes nausea. There were executions here; there could

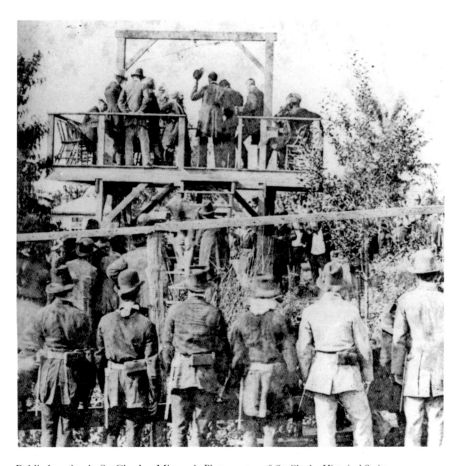

Public hanging in St. Charles, Missouri. *Photo courtesy of St. Charles Historical Society.*

be ghosts, or perhaps just knowing what happened here has an impact on personal feelings. The area is currently a landscaped walkway. Many interesting pictures have been captured and some audio recordings that could be interpreted as crowd noises, but in general the area is too cluttered. It is impossible to tell the ghosts from the natural phenomena.

However, this is not the story of two criminals. It is the story of an ethical man, a man who performed a service required, in spite of his personal convictions. Ebenezer Curtis was that man.

Mr. Curtis was called upon to be the executioner. His job was to stand on the gallows and pull the pin, a small metal bar that released the trap under the condemned men. From new black suits to grisly autopsies, a successful hanging is the result of experience and precise planning. There is a science to a hanging. If a man fell too far, his head would be ripped off. If the condemned didn't fall far enough, he would strangle to death instead of having his neck broken for a nice clean kill.

The execution took place without major incident, but everyone was aware of the potential psychological harm that could result from viewing a hanging. When the victim was well known, the public condemnation of the accused could be devastating. If the accused was unpopular, public antipathy could be overwhelming. When the townspeople were stirred, authorities often had to resort to extreme measures to prevent a lynching. On this occasion, one witness remarked:

> We came to where a crowd had assembled. After a time, officers brought out two men and hanged them. My father said, "I brought you to see the hanging to impress on your mind what happens to people who do not do exactly what you are told." I took months to forget the horrible sight and for weeks I woke up covered with the sweat of terror. I could see him twitch and his tongue hanging out and his protruding eyes.

This unidentified eyewitness was not the only person affected by the event. Ebenezer Curtis lived down the street in an upstairs apartment. A few months later, he committed suicide. He shot himself in the apartment but seems to have "flinched" at the last second. His body was found in the morning, against a gate in a narrow walkway leading to the apartment.

The site remains a dramatic and somewhat eerie place today. You can stand at the gate and look down the dark, narrow brick corridor. Often a

The apartment of Ebenezer Curtis. *Photo by author.*

cool breeze—some believe it is a cold wind—will drift down and brush against your skin. The opening at the far end places an interesting frame around the steeple of the church located one block to the west. A colony of bats also lives in this corridor, adding one more eerie element to the overall picture.

Unexplained electrical readings (EMFs) have been recorded more than once. People hear gunshots and mysterious groans echoing down the path. On one occasion, in the background audio track of a video recording, a clear voice was heard whispering, "I'm sorry…I'm sorry…"

In 2008, a documentary on the ghosts in the area was being filmed. The film team was using a remote-reading infrared thermometer to measure the air temperature down the corridor. While the camera was running, the temperature on the device dropped thirteen degrees and then went back to normal. It was as if someone or something had passed through the beam of the device.

There have been photographs of "shadow people" here. There are unexplained bursts of energy, and on occasion, cameras and cellphones will fail. The batteries will be completely drained. When the device is removed

from the area, the battery is restored. Perhaps the entity in the area uses the power in the battery to obtain the energy to manifest.

Sightings are reported here several times a year. The strongest manifestations seem to be in July and August. This is a popular site with ghost hunters and paranormal investigators. As a result, hundreds of photographs and multiple energy readings have been gathered. The area, beyond a doubt, is active, but there may be more here than just old, pitiful Ebenezer Curtis. After all, the narrow corridor is damp, mysterious and spooky. It does not take much of an imagination to experience ghosts here.

THE MURDER OF ELIJAH LOVEJOY

Number 310 South Main Street has a history of violence and death. Seth Millington, brother of Jeremiah Millington, built the house in 1799. It is typical of English architecture, and the bricks are handmade. In October 1837, Elijah Lovejoy was scheduled to preach for the Reverend Mr. Campbell, the Presbyterian minister of St. Charles. While in St. Charles, Lovejoy stayed with his mother-in-law here at 310 South Main. Conditions in the area were tense, and the anti-abolitionist faction made it clear that he was not welcome. The trouble began on Sunday as the services concluded. In Mr. Lovejoy's own words:

> *I preached in the morning, and at night. After the audience was dismissed at night, and when all had left the church but Mr. Campbell, his brother-in-law, Mr. Copes, and myself, a young man came in, and passing by me, slipped the following note into my hand:*

> MR. LOVEJOY,
> *Be watchful as you come from church to-night.*
> A FRIEND.

Lovejoy and his family walked from the church to the residence without incident. It was about nine o'clock, and it was a very dark night. The rooms were on the second floor with a dry goods store below. Outside, a flight of stairs provided access to the apartment. Elijah and Reverend Campbell sat conversing quietly, but at about ten o'clock, there was a noise at the foot of the stair.

Lovejoy called down through the door and asked what was wanted. The answer came: "We want to see Mr. Lovejoy, is he in?"

"Yes, I am here," Lovejoy said. A mob immediately rushed up to the room. Two men forced their way in and seized Elijah.

"We want you downstairs, damn you," they said, and they dragged Lovejoy out by his feet, his head bouncing violently on each step, leaving significant bloodstains. His wife attempted to stop them, and at one point one "southern gentleman" actually drew his dirk and threatened her. Her reply was to strike him in the face and push her way past. "You will have to take me before you can have him!" she screamed. Her energetic measures, seconded by those of her mother and sister, induced the assailants to release Elijah. They brought the wounded man back upstairs.

A short time later, the mob returned, breaking into the room again. Mrs. Lovejoy's health was delicate; she was seven months pregnant at the time. Her situation was truly distressing. The brutal attackers were indifferent to her cries and shrieks. They may have succeeded in this second attempt, but Reverend Campbell helped to force the mob from the room, and the house was cleared a second time.

The mob did not leave, however. The men were armed with pistols and dirks, and at least one pistol was discharged, but no one was hit. They rushed up the stairs a third time, and one man approached with a note signed "A citizen of St. Charles." The note was short, and it ordered Mr. Lovejoy "to leave the town the next day at ten o'clock, in the morning." He said no answer was expected and immediately left the room.

Elijah took a pencil and wrote a short note: "I have already taken my passage in the stage, to leave to-morrow morning, at least by nine o'clock. Elijah P. Lovejoy."

The note was carried downstairs and read to the mob. The men argued among themselves a bit more, but after a time, most of them drifted off to continue their discussion at Eckert's Tavern, a short distance up the street. With the efforts of the mob diverted, the family made their way out of the house and walked about a mile to the home of Major George Sibley. He provided a horse, and they made their way back to Alton, "thoroughly exhausted and utterly unfit."

Elijah Parish Lovejoy was a Presbyterian minister, journalist and newspaper editor. A short time after the incident in St. Charles, he was murdered by a mob for his abolitionist views. After graduation from college,

Lovejoy moved to Alton, Illinois, where he became editor of the *Alton Observer*. On three occasions, his printing press was destroyed by proslavery factions, and on November 7, 1837, he was shot five times with a shotgun. He died on the spot. Lovejoy was hailed as a martyr by abolitionists across the country.

This murder started a panic in the city of Alton. Banks failed, and property values shrank. Newspapers all over the country attacked the city for allowing this event to occur. This event inspired later abolitionists, including John Brown, and some historians believe this was the spark that ignited the Civil War.

No one was ever officially accused of the Lovejoy murder, but according to legend, a curse followed many of the ringleaders to their deaths. One of the leaders was stabbed to death in St. Louis; another was killed in a freak steamboat accident. Another died in a brawl in an Ohio prison, and one was brutally beat to death in New Orleans. Other reports say that "over the years, most of the members of that mob met violent and disgraceful deaths."

Ironically, the business in the lower level at 310 South Main is now a print shop. In the front window is an antique press, identical to the press used by Elijah. The stairs in the back have been rebuilt, and according to the current owners, the old stairs were covered in bloodstains that could not be removed. On occasion, while working late, the current owners hear the sounds of a violent crowd, and once or twice a year, the old printing press will move as if trying to print one more copy of the old newspaper. Other odd noises have been heard, but Elijah made his way east to die in another place. If Elijah's spirit still wanders, it probably is not here.

Perhaps one ghost is enough. Ebenezer, the repentant executioner, appears to still be hanging around. Strange noises are heard, and some people report feeling "unfriendly energy" that encourages people to do irrational things. It is mostly quiet today, but the site continues to generate reports. After all these years, 310 Main Street is still making history.

THE RUDE GHOST

One cannot help but wonder what is waiting on the other side. Will it be paradise? Will we meet long-dead relatives? Is there anything at all? Perhaps for some people, the other side holds no appeal. They simply hang around and continue to enjoy the world they knew in life. If they had a good life, a comfortable life, they may be reluctant to leave a good thing behind.

Over the years, humankind has developed different ways to deal with the inevitability of death. In the Middle Ages, few lived beyond fifty. A Victorian mother might have six children, hoping three would survive to adulthood. People simply did not live as long in those days, and this created a deep-seated fear of death. Could this fear be so strong in some people that they simply refuse to go away?

Today, we live much longer, and death has become somewhat remote. Most people under forty have never even seen a corpse. For most people, when death finally comes, it is usually in the clinical sterility of a hospital. However, in spite of all these changes, death is just as mysterious in the twenty-first century as it was in prehistoric times. The causes of death may change, and the frequency of death may change, but there does not seem to be a shortage of ghosts.

The Newbill-McElhiney House is a five-bay, fourteen-room, Federal-style house located at 625 South Main. Currently, the building houses a display of Haviland Pottery, but it was originally a residence built by Franklin and Polly Newbill.

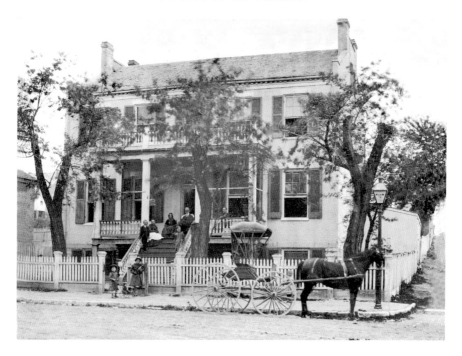

Newbill-McElhiney House, circa 1858. *Photo courtesy of St. Charles Historical Society.*

The three bays to the south are probably the original building, constructed in 1836, while the two bays to the north and the second floor were added to create an almost-symmetrical house. The exterior of the building is unaltered, except for the removal of the original chimneys and parapets. A two-story porch is centered on the main doorway and extends north and south along the front wall. A small two-story "L-plan" brick building is situated to the rear of the home on the north side. This building is rumored to have been used as slave quarters.

In 1858, Dr. William J. McElhiney and his wife bought the house, built the addition on the north and added the third floor. In typical Victorian fashion, they had fourteen children. Five of their daughters were named after southern states: Virginia, Georgia, Missouri, Louisiana and Florida. It seems they were a southern family through and through.

It is not known why, but in 1865 William McElhiney sold his home. However, he repurchased it two years later. Shortly before his death in 1883, he deeded the house to his daughter for one dollar, but during the probation of his estate, the house was subdivided between two heirs. The south half

was deeded to McElhiney's widow, while the northern part was granted to his daughter. Ownership was not consolidated until 1888, and for the next five years, the house was maintained as two independent residences. Finally, the home passed completely from the McElhiney family in 1895.

Clearly, during this period the family, and the house, was in turmoil. It is not clear which of the five daughters received title, but obviously the ownership was in dispute. To add to the confusion, there seems to have been a son who fought in the Civil War "on the wrong side." The McElhineys were slaveholders, and by some accounts, the rogue son was an abolitionist. Did the sale in 1865, after the Emancipation Proclamation was issued, have any connection to this? Was this action perhaps an effort to keep the house out of the abolitionist son's hands? Apparently, the son was killed in the fighting. Perhaps with this threat removed, William reacquired and moved back into his beloved home.

In any case, from this time on, it appears that no one in the house was content. The records are unclear, but it looks as if the McElhiney fortune trickled away, and after the family left, the house fell into disrepair. Finally, in the late 1960s the house was declared a historic site, and serious renovations occurred. But for the sixty-year period before these renovations, the information about the house is vague and sometimes contradictory.

From about the turn of the century until the renovations began, the house was once again used as a residence. It was probably used as apartments, but the records are unclear. It was vacant most of the time—nobody stayed for long. The noises, especially at night, were terrible, and a general feeling of sadness has been reported. Nobody was able to sleep there. There is even a rumor of a bordello operating from here for a short time. There is no evidence to support this story, but it cannot be ignored.

Currently, the Newbill-McElhiney House is privately held and contains an extensive display of Haviland pottery. It has been restored beautifully and sits proudly once again in the middle of Main Street. Most people think it is very quiet here, but there are a few people who report things that cannot be explained.

The manifestation located here is known as the Rude Ghost. It has never been experienced by a man. Often, ghost stories contain more detail than historical records. The strange events reported here have been passed around for many years and are well known up and down the street. There is little evidence to support most of them, but more than one firsthand account has

been collected. Also, the stories are often consistent in the details. There is no reason to doubt the reliability of the people sharing stories of the events.

More than one former resident tells that, often, when someone would walk into the back upstairs bedroom, she would see an impression in the bed, as if someone were lying there. The impression would even change shape, as if the invisible person were turning onto his side or moving to the other side of the bed. At least two of the people reported that when they observed the impression, they felt as if someone were offering an invitation to join him in the bed.

Several people living there report that while sitting on the edge of the bed, putting on shoes or something, someone would sit down next to them. There was no touching, but the impression on the bed was unmistakable.

One resident worked a second shift and would sometimes take a nap in the afternoon. She said that at least twice while she was living there, someone lay down next to her. The third time it happened, she moved.

> *My job has weird hours. Sometimes I don't get in until eight in the morning. I have to do regular things, shopping maybe, and I can only do that when the stores are open. Sometimes in the afternoon, I just need to sleep.*
>
> *A few weeks ago, I lay down, I didn't even change clothes, and I was just falling asleep. I felt something next to me, moving around. At first I thought it was the dog, but I could hear him barking outside the bedroom door. I turned over and I swear there was someone in bed with me. But I couldn't see a thing. I jumped up, let the dog in but there was no way I could sleep after that!*

Today, the museum occupies the entire building. No one lives here, and there is no bed in the third-floor bedroom. The collection is protected by a sophisticated alarm system, and tours of the museum are by appointment. As a result, the Rude Ghost has not been reported for several years. Apparently, even a rude ghost is not willing to sleep on fine pottery.

THE DOCTOR IS (STILL) IN

Even if no one sees the Rude Ghost anymore, strange things continue to happen at 625 Main Street. The building has been lovingly restored, and many people take photographs here. An early photograph shows the

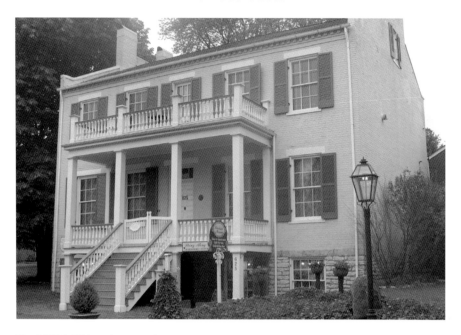

Newbill-McElhiney house as it appears today. *Photo by author.*

McElhineys sitting on the porch of the home on a fine summer afternoon. The doctor and his wife sit proudly on the porch, and several of the children pose on the steps and the sidewalk. Slightly to the left, a bit separate from everyone else, is what is believed to be the abolitionist son. Even here, it seems he is part of the family but not held close.

A number of photographs have been taken here while the museum is closed. No one lives here, but on occasion people outside report seeing a male figure moving past the security lights on the third floor. At least one photograph shows a shadow in front of the shutter on the right side of the door, in the same place the unpopular son sits in the old photograph. In this modern photograph, the shadow seems to be wearing a hat and smoking a corncob pipe. The details are uncertain, but the coincidence cannot be denied.

For the most part, the building is quiet. Just because a house is old does not mean it is "automatically" haunted, but the Newbill-McElhiney House is both old and, by all accounts, haunted. One sensitive person tells the following story:

I am always uncomfortable when I pass this building. I don't sense anything evil, but there is definitely something here that is unhappy. It really feels like it is a man, young and thinks there is much left to do. He is lonely; he likes women, and he gets angry when he is ignored. He does not seem to want to move on.

Again, one cannot help but wonder what is waiting on the other side. Death remains mysterious, and the remnants—the ghosts and the wonderful old houses—often supply stories that remain unfathomable.

THE LEGACY OF MISS AIMEE B

Ghost stories are almost always tragic stories, and what can be more tragic than a delightful, gracious woman living alone in a large empty house and the death of a very young child.

To the outside world, Aimee Becker had an active and philanthropic social life. But at the end of the day, all she had was her music, her books and her memories. One can't help but wonder, was this enough for this active intelligent woman?

Her younger sister, Adelheid, died at two and half years old. In such a short life, there was so much she never experienced. Her portrait is displayed in the house even today.

Sometimes people get caught after death. They don't seem to realize they are dead. They no longer have a sense of the passage of time. They are still wrapped up in their mortal existence and continue to do the same things they did while alive.

Francis Marten built the house at 837 First Capitol Drive in 1863, at the end of the Civil War. Labor was cheap, but materials were costly and hard to obtain. While on a business trip to California, Great-Grandpa Marten saw his dream house. He bought the plans from the architect, Henry Kister, and construction began. It was an ambitious project; records show that it took two thousand tons of soil just to bring the land to street level. The foundation is high-quality dressed limestone, and he employed expert local bricklayers to erect the main structure. The house is set back

The entranceway foyer of Miss Aimee B's home. *Photo courtesy of Miss Aimee B's.*

from the street, and even today the front lawn proudly displays several ancient oak trees.

Dramatic iron grillwork adds grandeur to the main entrance, and on top of the house, a fifteen- by fifteen-foot belvedere was used as an extra bedroom for any gentlemen guests. The windows of this room are colored glass, providing a wonderful view, and the morning sun would gently wake any overnight visitor. Delicate, attenuated columns support the porch, and in the front doors you find round arched upper windows and transoms filled with etched glass.

Just inside the main entrance is a dramatic walnut staircase with a formidable newel post and hand-carved railings. The two halves of the main floor can be closed off by two huge feather-grained pocket doors. The front parlor has an elaborate coal-burning fireplace with a beautiful marble mantel, but the upstairs rooms were heated by stones and circulators because fireplaces are too much of a heat loss.

Marten obtained the best of everything for the house. He bought the finest furniture, silver and porcelain. Guided by classic Victorian styles, a bare room was considered to be in poor taste, so every room was filled with objects that reflected the occupant's interests and aspirations.

Francis Marten was born in Prussia in 1824. Raised and educated in Prussia, he learned merchandising and distilling from his father, Kastien

Marten. In 1847, when he was twenty-three years old, he came to America, settling first in St. Louis. In 1849, he moved to St. Charles and established himself in the merchandising trade. In 1865, he turned to the operation of flour mills, and by 1885 he was the leading grain dealer in the area, shipping more than seventy-five thousand bushels a year.

Following the death of his first wife in 1851, Marten married Adeline Becker, daughter of Phillip Becker. One of their five children, Matilda, eventually married Franklin Becker. Franklin Becker was a merchant at the Rectern-Becker Dry Goods store and for thirteen years served as president of the First National Bank of St. Charles.

The Beckers lived in a house adjoining the Marten property on the east. Following the death of Franklin Becker's wife in 1894 the Becker family

Miss Aimee M.L. Becker in her late teens. *Photo courtesy of Miss Aimee B's.*

moved in with the Marten family next door. The Becker House, similar in style to the Marten House, has been destroyed to make room for a church parking lot.

Franklin Becker was the father of Aimee Becker, the last resident of the Marten-Becker House.

Aimee Becker was born in St. Charles in 1890 and was always described as a lady of refinement and a gracious hostess. The Martens and the Beckers owned the house for a total of 177 years. Miss Aimee said, "This was really the Marten home, but since I have lived in it for so long, friends call it the Becker home."

Miss Aimee graduated from Lindenwood College in 1908 and is listed as one of the charter members of the "Lindenwood Boosters Club of the World." In 1916, the club raised $100 for a college loan fund, and by 1917, the club had plunged into war work of all kinds in patriotic fervor. She seems to have maintained this attitude of charity, benevolence and excellence for the rest of her life.

Miss Aimee M.L. Becker died in 1984 at age ninety-four. She never married.

In her will, she left the Martin-Becker House to the St. Charles Historical Society. A short time later, it passed into private ownership, and in 1987, Miss Aimee B's Tea Room opened for business.

Miss Aimee's Legacy

According to reviews, Miss Aimee B's Tea Room maintains the feel of a grandmother's tasteful parlor. According to the proprietors, "We feel that Aimee's spirit is somehow a driving force here." The longtime staff members care for the house and listen to it closely; as a result, a number of unexplained occurrences have been reported here.

At least one customer advises, "Take a look around. There may be things in the air that are definitely off the regular menu." Mysterious sights, sounds and cold spots have been reported. People catch flashes in the corners of their eyes, hear distant voices and experience what seems to be "something tumbling through the air." Some say spirits may still live in the furniture, silver and woodwork.

Aimee's younger sister died when she was only two and a half years old. We do not know how she died, but she was loved and missed. Her classic

Victorian portrait is still displayed in the dining areas. Young Adelheid was a pretty child. It is hard to look at the panting and not be affected. The owners are sensitive to the child, and occasionally the portrait is moved from room to room "so she has a different view and can meet different people." More than one customer has been caught talking to the painting as if the child were still here. According to co-owner Sherry Pfaender, Adelheid has called out from her portrait when left alone. A distant voice says, "Mommy, Mommy."

"I heard it on two separate occasions," Sherry recalls. "I was in the next room; it was very clear. I was a bit concerned." The young voice seems to be lonely and perhaps a bit frightened. Maybe she does not want to be alone.

A few years ago, country singer Crystal Gayle visited Miss Aimee B's. Crystal posed for a picture with the portrait of Adelheid. When the photo was viewed later, a strange mist seemed to be coming from the portrait. The mist was not visible when the picture was taken. Other people report similar events. Aside from the eerie Victorian darkness of the image, many people agree that there is "something" about the painting.

Tom, Sherry's husband, has also experienced the unexplained. According to accounts, Miss Aimee delighted in the radio and classical music. One night, while making late-night repairs in the cellar of the restaurant, Tom had the radio tuned to a soft rock station. Suddenly, it switched to a classical station. He changed it back to soft rock, and it switched to classical again. Tom then decided it was time to go home.

Judy Howell (co-owner) has tales of unexplained reflections—of a sight, sound or feeling, something in the air. Judy said that while working late one night, she "was in the back room downstairs and heard bumping. I went into another room and turned up the radio. After a few minutes, the radio went dead. At that point, I turned out the lights and left."

Staff, customers, cooks and servers have special stories. More than once, in the gift shop upstairs, a small pile of pecans has been found left on the counter. In life, some people say Aimee was very fond of pecans. Perhaps she leaves them behind as a gift, just a simple kindness.

One customer reported:

> *I just feel like Miss Aimee is there watching. One time, I was shopping upstairs, and I left my cell phone sitting near a stack of books. I went into the next room, no one else was upstairs, and I heard my phone ring. I went*

Adelheid died when she was two and a half years old. *Courtesy of Miss Aimee B's.*

back to pick it up and there was a few pecans sitting on it. Maybe Miss Aimee was watching out for me.

Judy also tells a story of another gift, one to a young bride. Aimee never married, but she was very social and knew how to entertain. As described by some, Miss Aimee always provided divine cuisine. While preparing for a wedding reception, everyone was surprised to find more than fifty spoons stacked neatly on the serving table near the wedding cake. All of the tables in the room had been arranged by the staff, and these spoons had been moved. No one knows how they got there, but the bride was touched. She said, "It was as if Miss Aimee wanted to give me a gift, and this was the only thing she could do." She continued, her eyes glistening, "I will remember this for the rest of my life. Thank you Miss Aimee."

The home of Miss Aimee B as it appears today. *Photo by author.*

Miss Aimee's house continues to be a place of sights, sounds, feelings and memories. The current owners, Sherry and Judy, maintain that Miss Aimee's spirit is a driving force for excellence here, and at times it seems as if Aimee's spirit is still actively participating in day-to-day activities. With all the events reported in the daylight, one can't help but wonder what happens at night when the spirits of Miss Aimee and Adelheid are in the building alone and unobserved.

THE MOTHER-IN-LAW HOUSE

About two in the morning, then, I was awakened by some sound in the house.
It had ceased ere I was wide awake, but it had left an impression behind it as
though a window had gently closed somewhere. I lay listening with all my ears.
Suddenly, to my horror, there was a distinct sound of footsteps moving softly in the
next room. I slipped out of bed, all palpitating with fear, and peeped round the
corner of my dressing-room door.
—*Arthur Conan Doyle,* The Adventure of the Beryl Coronet

The Mother-in-Law House, located at 400 South Main, is probably the best-known haunting on Main. It is the first double house built in St. Charles, and may be the first double house west of the Mississippi. It was built about 1867 by Francis X. Kremer. Today, we would call a double house a duplex.

The front half and the back half of the structure were almost identical, separated by a solid brick wall. The front side, facing Main Street, proudly displayed an ornate portico with arched double windows on the second floor. The main entrance was on the north side of the building, with only a strong door and a simple porch. In the beginning, both sides were furnished and finished to be exactly the same.

After arriving in St. Charles in 1853, Francis X. Kremer leased a large flour mill and purchased most of the 400 block on Main Street. In addition

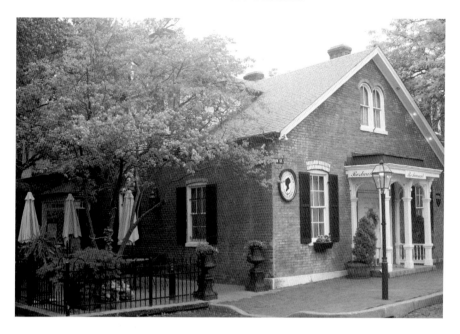

The Mother-in-Law House as it appears today. *Photo by author.*

to the residence, the actual mill was located here, as was a brick grain warehouse. According to city records, Kremer insured the structures against fire in 1870. However, in 1876 the business was destroyed by a tornado. He lost almost everything, but Mr. Kremer was not discouraged. He repaired the double house and remained in St. Charles until his death.

Local lore indicates that Mrs. Kremer was unhappy living away from her mother. The double house was constructed so that they could live near each other but separately. Recently, the current owners paid $150 to obtain a copy of the abstract for the building, hoping to discover, from the record, the mother's name. However, when the document was examined, they found that she had signed the document with an "X," witnessed by her daughter. Mother's name is lost in history, but people in the area refer to her as Christina.

There are stories about how Christina was abused, neglected and mistreated, but there is no evidence to support these rumors. However, it seems that Christina was a lonely woman. Perhaps she was not happy in St. Charles and missed her own home. Perhaps as she aged, she missed the social life. As time passed, even her daughter, living just a few feet away, visited less and less.

The Mother-in-Law House

By most accounts, Christina was not healthy; no one expected her to live twenty-two more years. It was all she could do to drag herself out of bed and get dressed. She would sit in a chair all day, watching as the world passed by on Main Street. She died a very sad and lonely woman. She was not neglected so much as ignored.

Today, the building is occupied by a fine restaurant. There is a pleasant dining room on the main floor and a large meeting room downstairs. A few years ago, the owners redecorated, and the restaurant now enjoys a beautiful Victorian theme. Christina would have loved it. According to accounts from customers, servers and other visitors, Christina may still be here.

The popular table here is table number one. It is located about where Christina spent most of her time, near her bed and chair. Visitors report that on occasion, it is almost as if an additional person is at the table, one who is glad to have visitors. The presence is not scary or spooky, but sometimes Christina will do her best to get people's attention. When diners sit down, they will find silverware missing, and the servers will find it later sticking out from behind a photograph or up on a shelf. Sometimes the water glasses will be tipped over, and it will be necessary to completely redress the table.

In addition to private bookings, the room downstairs is used by a number of local organizations, including the local Sherlock Holmes discussion group. Some members report cold spots, strange noises and flickers in the corners of the room. The group discusses Holmes's rational techniques and is not willing to call these events ghosts. In Arthur Conan Doyle's *The Memoirs of Sherlock Holmes*, Holmes reflects:

> *It seemed to me that a careful examination of the room might possibly reveal some traces of this mysterious individual. You know my methods. There was not one of them which I did not apply to the inquiry. And it ended by my discovering traces, but very different ones from those which I had expected.*

According to a newspaper article published in 1988, the owners felt that business at the Mother-in-Law House was uncharacteristically bad. Restaurant consultants advised them to change the place settings. Business consultants told them to change the check and accounting system. Tourism consultants suggested advertising in travel magazines. Finally, almost in desperation, they called in a psychic.

According to Donna, the owner:

> *None of the consultants' recommendations worked. And I had noticed strange things about the restaurant. Customers never stayed long when they were on the right side of the restaurant. They ate quickly, never laughed and paid their bills quickly, as if they couldn't wait to get out. Customers who were seated in the left-hand side lingered, laughed and seem to enjoy themselves. Though I served the same food to all patrons, I would receive complaints from people who sat on the right. They would say the coffee is not good or that the chicken amaretto is too salty.*

Many people believe that some hauntings occur when something happens in a location that "scars" the location. This scar acts as a key, causing the event to reoccur. Often, when an injustice has occurred and an exceptionally strong will is involved, the spirit keeps trying to make a loud psychic noise. The person wanted attention while he was alive and continues to react to the situation that upset him. Christina had the entire right-hand side of the building to herself, but she felt isolated from her family, who lived on the other side of a formidable brick wall. Apparently, the lonely feeling continues to haunt the right side of the building, even after the building was transformed into a restaurant.

According to the psychic, "That's why they don't laugh. The mother-in-law's negative imprints are still here."

Donna followed the advice of the psychic, who believed Christina's spirit had to be appeased and told the owner to "start putting more flowers on the right side of the restaurant. And tell the mother-in-law you love her every day."

Still, Donna says she is caught between two value systems: science, with proven, pragmatic systems; and traditional spiritualism, where anything is possible but not verifiable. Donna says she finds paranormal phenomena fascinating but wishes "it would be studied more like a science." She continues, "I don't know if there is a ghost in the restaurant. I do believe we have strong negative imprints, but not necessarily the mother-in-law's ghost. Customers get very disappointed when I say that. They want ghosts."

The Research—and Reports—Continue

More than one paranormal group has certified the location as haunted, including the Mid-America Paranormal Society and the Paranormal Task Force. Both of these groups are strongly based in scientific evaluation of paranormal locations, and both report a number of anomalies that could be ghosts. In addition, there is a local ghost tour that passes this site eight to twelve times every month. The tour participants have collected a large number of photos with unexplained lights, shadows and misty smudges.

The director of Mid-America Paranormal Society says:

> *We have not performed a full investigation at the Mother-in-Law House, but casual observations indicate some kind of activity here. We have gathered significant photos and, on several occasions, very high electromagnetic energy readings. I cannot say yes, there is a ghost here, but there is definitely something unexplained. We need more investigation.*

There is an apartment above the restaurant, and staff members sometimes hear strange things:

> *There was someone pacing upstairs in the vacant apartment. Everybody heard it. It sounded just like a person going from room to room. One guy even heard someone on the stairs, and there was no one there. I have been around ghost stories all my life, but this is too close. This is real.*

While the ambience of the building could never be called creepy, the encounters with Christina continue. Lights mysteriously turn on or off; items are misplaced or just go missing completely. Objects move around the building after hours. "She is not mean," said one employee. "She just wants us to notice her." Everyone seems to agree that the entity at the Mother-in-Law House is peaceful and not something to fear.

Today, business at the restaurant is good, and everyone coexists with Christina. Every night, when the staff members leave, everyone says, "Goodnight Christina, we love you." It started out pretty much as a joke with the staff, but now it is taken pretty seriously.

As a result, Christina is not experienced as often these days. Her spirit still lingers, but she may be almost content. In a strange twist, many people

find this new situation to be sad. Perhaps, after all these years, all Christina wanted was a bit of attention.

"You will not apply my precept," he said, shaking his head. "How often have I said to you that when you have eliminated the impossible, whatever remains, however improbable, must be the truth?"
—Arthur Conan Doyle, The Sign of the Four

THE FIRST STATE CAPITOL

Before Missouri was granted statehood, various locations in St. Louis served as the seat of government for territorial affairs. As statehood became a certainty, the search began for a site to use as the permanent seat of government. Ultimately, an undeveloped tract of land located in the center of the state overlooking the Missouri River was chosen to become the City of Jefferson, Missouri's permanent capital. However, until the new capitol building could be constructed, the state's first legislators needed a place to meet. Nine cities competed for the honor of hosting the state's temporary seat of government.

One of these cities was St. Charles, and it was described in the proposal as "a growing trade center, located on the Missouri River with easy access to the most rapidly growing areas in the state via the river or the Boonslick Road." The citizens of St. Charles pledged that if their city were chosen as the temporary capital, they would furnish free meeting space for the legislators. On November 25, 1820, Governor Alexander McNair signed a bill making St. Charles the first capital of Missouri. The state's first legislators met in St. Charles for the first time on June 4, 1821.

City fathers established a town board of trustees and guaranteed that the city would provide a seat of government "free of expenses to the State." The board agreed to pay Ruluff Peck $100 a year for the use of the second floor of two newly constructed adjoining Federal-style brick buildings. Large arches were cut in the walls of the second floor to create the Great

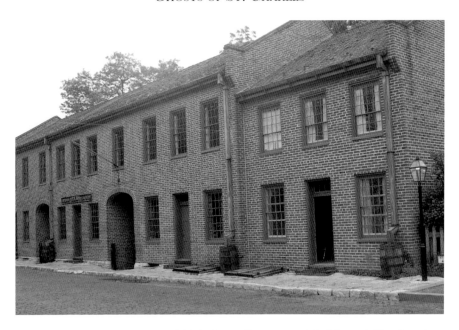

The restored first capitol building. This is the smallest state park in Missouri. *Photo by author.*

Assembly Hall. This structure, built in 1818, is actually three buildings under one saddleback roof. The two buildings on the south end, with the arched alleyway leading to the ferry, were owned by Ruluff and Charles Peck. The first floor was used as their residence and store. The second floor served as the Great Assembly Hall from 1821 to 1826. A third building on the north end was the home of a carpenter, Chauncey Shepard.

The rooms on the second level were used for the governor's office and committee rooms. Missouri legislators met here from June 4, 1821, through October 1, 1826. Missouri's first legislators—some of them frontiersmen and others of the gentry—met to undertake the task of reorganizing Missouri's territorial government into a progressive state system. Legislators arrived on horseback, in elegant carriages and on foot. They wore fur coats, coonskin caps and leather moccasins. According to one account, Governor McNair was often attired in "a beaver hat and a frock coat." Local residents and tavern keepers offered room and board to state officials at a rate of $2.50 per week. However, even this modest rate was beyond the means of many of the members. The legislators were possessed with good appetites, and some local citizens suffered significant losses under this arrangement.

Heated debates over states' rights and slavery filled the rooms of the temporary capitol chambers. Four Missouri governors ran the state's affairs from here until the new capitol in Jefferson City was ready.

After the capital was moved to Jefferson City, it was business as usual in the Peck brothers' building. However, about 1900, the buildings and neighborhood around the first state capitol began to slowly decay. The Peck brothers essentially disappeared from the public records, and a number of other operations were located here, including what may have been a paint store and several other retail businesses. Windows were broken, the roof leaked and the building was almost unusable.

In 1960, the State of Missouri bought the building and started a restoration project that lasted ten years. The governor at that time, James T. Blair, was prompted to make these renovations by concerned citizens of St. Charles who recognized the value of historic buildings. The capitol building is currently among the smallest state parks in Missouri; it is officially listed as being only .66 acres in size.

The second floor has been restored to reflect how the rooms used by the new government would have looked in 1821–26. The Peck Brothers Dry Goods & Hardware Store has been refurbished and reoutfitted. Inside, you will find what a typical store in the 1820s would have had on hand, including cloth, dishes, flour, tobacco, cooking appliances, candles, tools and traps. Stores of this era typically used the barter system, with fur pelts being the most frequent form of payment. Many of the common types of fur pelts used as barter are on display. The family residence of Ruluff Peck has also been restored.

Adjacent to the historic site building is the interpretive center. Admission is free, and it offers two floors of exhibits and an orientation show. For a nominal fee, visitors can take a guided tour through the actual restored and furnished rooms where the Missouri state government was created and first practiced.

During restoration, the foundations for several outbuildings were uncovered. Two wells, or perhaps cisterns, were found, along with two utility buildings. It is believed that the smaller of the utility buildings was used for food storage, taking advantage of the reduced temperatures coming from the well, but the purpose of the second, larger building is unknown. It appears as if this building was intentionally destroyed, along with any records pertaining to it. These ruins were examined and excavated a few

years ago. Speculation includes a summer kitchen, servants' quarters (that is to say, slaves' quarters) or storage. It is hard to say. Some say the larger building was a holding cell for runaway slaves.

During the Civil War, Missouri was cut in half. As part of the Missouri Compromise, the top half of the state was free and the bottom half was slave. If you were in St. Charles, you were a slave. If you could make it across the river into St. Louis County, you were free. After the Emancipation Proclamation, outbuildings like the one behind the capitol building became an embarrassment all over the country. It was not unusual for buildings of this type to be destroyed and their very existence to be denied.

Evidence to support or deny this position cannot be found. There are no newspaper accounts, deeds, building records or personal accounts. The only evidence we have is in the form of personal stories passed down through the years. Odds are, this building was a holding cell of some type. Even if it was not a holding cell for slaves, it is likely that more than one person died while incarcerated there.

A number of ghostly events have been reported, and recorded, here. Just after sunset, looking west down the corridor, one can glimpse the edges of the ruins. On occasion, an unexplained mist will be visible just inside the wall of the holding cell. On several occasions, the distinct outline of a person can be seen, and energy phenomena, also called orbs, frequently appear. Unfortunately, many of these events have natural explanations. The humidity from the grass, summer insects and airborne debris can account for many of the "mysterious" forms. However, the most interesting objects seem to cluster around the holding cell. These events have high credibility.

A short time ago, some very interesting bright red objects appeared in a photograph. The objects hovered in the cell, moving slightly in almost random patterns but staying inside as if confined. However, when the image was examined closely, it turned out to be a happy rabbit family, munching away on fresh grass as the light from the street reflected in their eyes.

Today, the area behind the restored building has a quiet things-put-to-rest feeling. But there is no shortage of violent frontier stories in the town. Local tradition holds that more than one duel occurred on the parade grounds behind the capitol. Keep in mind that the area between the building and the river was the front of the building in 1820. It was a public meeting space and was used for many things.

Dueling was never legal in St. Charles, but often the authorities looked the other way. There are several accounts of assaults or incidents of self-defense reported here. However, it is unlikely that an assault would be carried out with a sword or that after an incident of self-defense a set of match pistols would be confiscated.

You may ask, why would someone choose this public place for a duel? It was possible to maintain plausible deniability: "But officer, we were not dueling. If we were dueling, would we choose this public place? It was self-defense." In the end, the participant with the strongest political ties would be charged with a lesser crime, and the entire incident would be forgotten.

THE CHOLERA EPIDEMIC

Even a casual visitor to some of the area graveyards will notice that many stones list a date reading, "Died: 1849." The 1849 dates are out of proportion to those of other years because this is the year when the area had a severe epidemic of cholera. In 1849 alone, about one-tenth of the area population died from the disease. According to reports in the *Western Journal*, 8,445 people died that year (including in the St. Louis area), with 4,285 deaths attributed to cholera. A complete list of deaths is not available, and cemetery records for many of the victims do not exist. The *Missouri Republican* usually reported five or six deaths a week, and in July 1849, reported deaths numbered almost 150. By some accounts, this number was only about 5 percent of the actual deaths.

This disease had been known in India for a long time. About 1800, it began to move westward along trade routes and soon spread throughout Europe. Before long, one million or more lives were lost there. Soon, the disease appeared at several points along the routes to New Orleans, and it quickly spread up the water routes along the Mississippi.

The disease seemed to prefer younger victims. One list from St. Louis shows the average age of death to be around thirty years old. Doctors did not know the method by which the disease was spread, and they did not have any effective treatments. The most widely accepted explanation was miasma, or vapors from rotting vegetation. Many remedies were offered, including opium, castor oil, calomel, powdered mustard seed, brandy and tea made from snakeroot. A number of patent medicines were available,

and extraordinary claims were made. Well's Cholera Specific, Dr. James's Carminative Balsam, Son's Pain Killer and Gould's Cholera Specific were made available.

One of the most sensational remedies came from southern Illinois and was called the Egyptian Anodyne. It claimed to be based on a formula recorded in hieroglyphics on a papyrus scroll found beneath the head of an Egyptian king buried five thousand years earlier. People were desperate and would try anything.

Once contracted, the disease killed quickly. Death often occurred within four or five hours. One doctor, addressing a group of medical students, said, "The first symptom of cholera is death."

Local undertakers were overwhelmed. There simply was not enough burial space in the area. The heat of summer and the large number of bodies created a desperate situation. By some accounts, there may have been a mass grave near the grounds of the capitol building, just to the west in what is now Riverfront Park, in an unused area on the banks of the Missouri River. A large, shallow trench was dug, and the bodies of slaves, poor farmers and unidentified travelers were dumped here and forgotten.

These foundations were uncovered during renovations of the first state capitol building. *Photo by author.*

The story of the mass grave cannot be confirmed. There are no official records, and the area has been flooded many times since then. Any bodies would have long since been washed away. There is an area in the park that remains unused. More than one sensitive person has reported an uncomfortable atmosphere in the area of the alleged grave site. By all accounts, there were more bodies than were listed in official records. They had to have been put somewhere.

One local resident reports:

> *I hate this spot. I was down here for a picnic a few months ago, and our Frisbee flew over there. I went to get it, over there, and I got sick to my stomach. I couldn't move. I just doubled over and fell down. My boyfriend ran over, and helped me up. As soon as I got away from that spot, I was OK. I have always been sensitive, I can't go into cemeteries, and stuff like this really hits me hard. There is something over there, I don't know what.*

UNOFFICIAL GHOSTS

Officially, state park officials do not tell ghost stories. Unofficially, rangers here reported a number of strange events. In addition to the standard knocks, bangs and creaks found in older buildings, people report voices, footsteps and music. During tours of the building, people on the first floor hear people moving about in the empty council chambers above. On occasion, it seems that heated debates are taking place in the chambers, but no one is visible. In its day, the capitol building was used as a civic meeting place. Sometimes ghostly echoes of what could be frontier concerts are heard as if from a great distance. People report cold spots and feathery touches, and on occasion furniture will be moved.

Several years ago, a film crew was here making a documentary. More than one person on the crew said that they were uncomfortable while inside the building. They decided to set up a camera and let it run all night, while the building was empty.

They checked on the equipment in the morning and found that the camera tripod had been knocked over and the film torn from the camera. Any images or events that may have been captured during the night were lost.

Today, the park has a quiet, laid-back feel. The only activity here is from the tours and visitors to the interpretive center. The grounds are closed up and closed off at night. Even late-night visitors to this part of Main Street treat the building with quiet respect.

One visitor shared the following story:

> *Some people hear things, others see things. Not me, but I did feel something I can't explain. I was standing outside, near the entrance, and I felt a hand on my shoulder. The fingers grasped me, and I turned to see who it was. There was no one there. The hairs on the back of my neck stood up, and to this day, I don't know who, or what, it was. But it was there, and it was very real.*

THE GHOSTS OF LINDENWOOD UNIVERSITY

In 1821, George Champlin Sibley, along with his sixteen-year-old wife, Mary Easton Sibley, were stationed at Fort Sibley (more properly known as Fort Osage) "to promote peace, friendship and intercourse with the Osage tribes, to afford them every assistance in their power, and to protect them from the insults and injuries of other tribes of Indians." They spent several uneventful years here living a comfortable frontier life, while still enjoying many of the comforts of a civilized life. They were well supplied and well fed, and Mary even held piano concerts for the mountain men and traders visiting the fort. In 1816, she even played host to Daniel Boone. He arrived at the fort in April and spent two weeks there.

However, in 1826, George cosigned a note for $20,000. By some accounts, his partner defaulted, disappeared and left them with next to nothing. Sibley took possession of his former partner's assets, which consisted of little more than 120 acres in St. Charles. When the Sibleys left Fort Osage, Mary was twenty-eight and George was forty-six years old. They loaded their meager belongings onto a riverboat, came to St. Charles and moved into a house at 230 North Main. Mary's father lived at 201 South Main, and a short walk enabled Mary to see her father every day, a practice she kept up for the rest of his life.

Shortly after arriving in St. Charles, the Sibleys went out to inspect their property. The grounds were so overgrown that they would have to "clear away enough thickets in order to obtain a view of the land." The major and his wife stood on the summit of the hill covered with a large stand of

The original Lindenwood University building, now called Sibley Hall. *Photo courtesy of St. Charles Historical Society.*

beautiful linden trees. About 150 feet above the Missouri River, they resolved to lay the foundation of a school for young ladies. In 1827, a log cabin was erected, and the Lindenwood School for Girls opened its doors. The generous grounds, groves and gardens provided ample space for reading, recreation and retrospection. On July 4, 1857, the cornerstone was laid for a proper building, three stories high, 73 feet long and 48 feet deep. Sibley Hall, the brick building we see today, was built over the original log cabin and was the only building on campus until Ayres Hall was constructed in 1908. Today, Sibley is used as a residence hall and is the oldest building at Lindenwood. Many young ladies were educated under this roof and have been "sent out to fill honorable positions in society."

In 1833, Mary wrote in her journal:

> *I commenced this spring, the little school I had last year consisting of seven or eight young girls—on the plan I have thought necessary for the good of the rising generation. That is that women instead of being raised helpless and dependent beings should be taught a habit of industry and usefulness.*

Life was hard in St. Charles in the nineteenth century. In his journal, George Sibley recorded deaths from cholera, yellow fever, miscarriages, stabbings, suicides and "brain fever." Among others, he wrote of the tragedy of the Alderson family. Benjamin Amos Alderson lost his wife in 1847 and then buried his daughter and her infant sister next to his wife on March 23, 1848. Four days later, his four-year-old son, George, died of scarlet fever, followed on April 4 by Martha, "the eldest, being eight years old." She was buried next to her sister, "quietly and silently—very few people being present." Then, on Sunday, April 9, 1848, his third daughter, Mary, died and was interred just after sunset. George Sibley observed, "Thus has Mr. Alderson been bereaved of his wife and five of his children within six months."

By 1853, Lindenwood was a full-fledged women's college. Mary continued to be at the school every day, and to say that she touched the lives of her students would be an understatement. Mary regulated all of her student's waking hours in study and recreation. When lessons were completed, she often read to them or entertained them on her piano with the fife-and-drum attachment. Often, she would sit with them in the common room and embroider. She looked upon women as the "nobler sex," and as a result, in addition to literature, grammar, writing, spelling and other subjects, Lindenwood's program included instruction in "Intellectual, Moral and Domestic issues."

At Fort Osage, and later in St. Charles, Mary Sibley frequently traveled by horseback rather than in a carriage. She made almost daily trips to town, to get the mail if nothing else. According to one historian, "She rode a white horse, very gentle, with a young servant perched behind to open gates." Her distinctive appearance was well known all over campus and all over town.

In 1851, George Sibley became a semi-invalid, but he continued to work on improvement projects in St. Charles. He also took on the almost full-time job of establishing Lindenwood as a premier college for women. In later life, he was mostly bedridden but continued to read, and he wrote on current topics for several newspapers. He died at age eighty-one on January 31, 1863. He was buried in the graveyard laid out on the Lindenwood campus.

After George's death, Mary attempted to carry on. She refused to wear black, saying she did not want to upset the girls. However, everyone knew

The Sibley Family Graveyard, located on the campus of Lindenwood University. *Photo by author.*

she was hiding a deep hurt. Without heeding anyone's advice, she sold her house in 1864 and moved to a house she built in Lafayette Park in St. Louis. She continued to travel and sometimes visited her sister in New York. She made several trips to Europe and visited many major cities in the United States. She was by all accounts "a very pretty old lady" and could often be seen, hobbling along with her cane, in the park at Lafayette Square.

Mary had friends and relatives in St. Louis, but she was not happy away from Lindenwood. It also appears that she was a poor manager of money and was lost without George. In the late 1860s, she was compelled to sell her home in St. Louis and move back to St. Charles. She purchased a small cottage near the college. She was pleased to discover that in her absence her girls had not forgotten her. In her late years, she maintained her vivaciousness, vitality and physical strength, but on Thursday, June 20, 1878, she died quietly in her sleep. She was seventy-eight years old and was buried in the plot beside her husband, her sister-in-law, her mother and "Little Willie," the son of the first president of Lindenwood.

AUNT MARY TODAY

Today, Lindenwood University sits on more than five hundred acres and offers more than 120 undergraduate and graduate programs to more than 14,500 students each year. There are many stories about ghostly encounters in many locations. Before her death, Mary Sibley promised her students that she would always be with them and watch over them. Sightings of her ghost, along with other paranormal and poltergeist activity, seem to indicate that Mary Sibley—and perhaps others—has actually stayed behind.

Mary Sibley did not dwell on the fact that she was mortal. Mary did not plan ahead because she had so many short-term goals to accomplish. She never thought she was going to die, and as a result, many of her goals were not met. It is believed that she still inhabits the campus, attempting to complete some of these projects and, of course, keeping an eye on her beloved students.

The legend of Mary Sibley's ghost began shortly after her death. According to a historical essay, students began to experience unexplained phenomena as early as 1879. Locked doors would be found standing open. Footsteps would sound in the night, echoing down empty halls. Students reported seeing Sibley materialize on the main staircase, and as she descended the stairs she would fade away. With such a long history and so many students over the years, everyone in the area seems to know someone with a personal experience on Lindenwood campus.

In Sibley Hall, the ghostly activity seems to be focused on the third floor. Students report seeing blue orbs and misty figures. Others claim to wake in the middle of the night and find their mattresses floating in the air. Past residents claim that furniture moves, pictures turn and voices emanate from vacant rooms. Parents tell of daughters who stay at home rather than in their dorm rooms because "they feel a presence when no one else is there." Other students report electrical items turning themselves on and window shades that suddenly fly open. For a time, part of Sibley Hall was closed off and boarded up. There were no renovations going on, and no repairs were being made. This part of the third floor is where the most ghost activity has been reported. According to some reports, this area was secretly, efficiently and undetectably sealed up. Official records related to the construction have not been located, and there is no evidence of a boarded secret area at this time.

Mary's famous piano, still on campus, will sometimes play with no one at the keyboard. Occasionally, the sounds of a fife and drum will be heard, accompanying the mysterious keyboard musician. People have been saved "by a ghostly hand" preventing a fall down the stairs. Others have received a sharp swat on the behind if they come in late or misbehave in some fashion. Sibley Hall includes a chapel, and "the chapel is indeed a little scary at night with the lights out." Residents say the organ also plays in the middle of the night and can be heard throughout the building in the dark hours of the night.

On occasion, incoming freshmen wake up in the middle of the night and claim they can't sleep in their rooms. They flee to the lounge, huddle together and sleep on the couches. However, most people believe that the lounge is the worst place to sleep. Mary's picture is above the fireplace. The piano is there, and the room seems to always be cold. Perhaps, in spite of the spooky environment, Mary is there to comfort the homesick newcomers.

One summer, between terms, Sibley Hall was undergoing renovations. No one was in the building, except the workmen, and all of the doors were kept locked. One day, the workers heard girls' voices and giggles on the third floor. There were loud sounds like drawers being opened and closed and the sound of furniture being dragged across the floor. They simply assumed that several young ladies were upstairs doing some work of their own and were not concerned. At quitting time, several of the men went upstairs to check the doors and to make sure the ladies could get out. They climbed the steps and found that the upper floors were completely vacant. No one was there. No one had been there for a long time. The setting sun filtered through the unwashed windows, and the dust on the floor was undisturbed. Everything was deathly silent.

Campus legend states that Mary Sibley returns to the school every Halloween night. Some say she rides across the campus on her white horse, a small boy perched behind her. Others claim she simply rises from her grave and walks in Sibley Hall. According to a much-told story, several years ago a student decided to dress up in old-fashioned clothes, like Mary Sibley, and frighten the other girls. She went into the lounge to play Mary's piano but saw another girl dressed as Mary Sibley already there. She thought it was another student trying to play the same joke, but then the mysterious girl lifted her head. The student realized she was face to face with the real Mary Sibley. The girl screamed and fainted. Her Halloween prank was interrupted by the real thing!

Lindenwood's current students continue to share stories. Some freshmen admit that they were scared at first, but as time passed they realized there was nothing to fear. One student related, "I was walking out the door, late for class, and I felt something jab me in the back. But when I turned around, no one was there, but I ran and made it to class on time." Others report seeing a woman with black hair and black clothes sitting on the hallway couch, reading a book. It is said that Sibley's ghost greets every incoming freshman on the Sibley Hall staircase.

One Sibley Hall resident who did not want to be identified told of a friend who lived in the dorm. Her friend's mother had just died, and she was going through rough times. She was upstairs in her dorm, crying on her bed, when she felt someone sit down beside her. She could not see anyone, but she felt as if Mrs. Sibley was doing her best to provide some comfort.

Another student related:

> *I lived on the second floor last year, and I heard footsteps and drawers slamming all the time in the room above me. One night I went upstairs to tell the girls to be a little quieter. The girl that lived there said she had just gotten out of the shower and it couldn't have been her.*

When confronted with rumors of this most famous ghost, Lindenwood administrators merely chuckle and will not comment. However, in one case, when a nervous incoming student asked about the ghost, the school president quietly chuckled but did not deny the stories or her existence. It appears as if Mary Sibley ignores the "official position." She continues to hang around and take care of her school and students.

She Is Not Alone

Mary may not be the only ghost at Lindenwood. There has been more than one suicide on campus and at least one gruesome murder. During World War I, a girl living in Sibley received a telegram. Her fiancé, fighting overseas, had been killed. She went to the attic and hanged herself. Students on the third floor claim to hear creaking noises from the attic, sounds similar to a rope swinging from a rafter. Many students living there have pledged that they will never set foot near the attic. But a few have, and they say it is bitter

cold at the foot of the steps. On occasion, the attic door, though unlocked, will not open. It seems that some students get this story tangled up with that of Mary's death. Many students tell the story as if Mary had committed suicide by hanging, but Mary died quietly in her sleep, alone in her bed. However, that does not seem to stop Mary from visiting on occasion.

The campus theatre, as well as the library, is said to have its fair share of ghosts. Just prior to a recent performance, one of the actors came backstage shaking in fear. He had turned to say "excuse me" to a man standing in the stage exit wings. He turned and realized that he was alone on stage. On another occasion, a technician was walking toward the lighting and control area. When she got to the top of the stage ramp, she suddenly jerked and jumped out of the way as if she was trying to avoid hitting someone. Later, when asked about the incident, she replied that she was getting out of the way of a man in a dark suit and hat. She assumed it was one of the costumed actors, but none of the actors was in the building at the time.

Like many theatre ghosts, no one seems to know who he is (was), but he continues to visit, usually at the start of a new production. Perhaps he was a director or teacher and, like Mary Sibley, continues to watch over his students. Strange mists have been reported, like nebulous actors on the stage, and late at night, chills follow people around like an aggressive usher. After the applause fades, the curtain falls and the audience returns to the real world, theatres become dark and silent places. But the facilities here, like many others, are not always completely empty.

The Butler Library is only a few hundred feet from Sibley Hall, and there are ghosts reported here. So far, no specific history or person has been identified, but the inside of the building is dramatic, and the floors in the main building are unusual. The floors are translucent fiberglass. They are very strong, but you can easily see people walking around above. It is easy to understand, with this unusual design, why ghost stories are inevitable. The Butler Library was opened on June 3, 1929; the estimated price to construct the building was $200,000. In 1968, new wings were added to the east and west ends of all three floors of the building. Thousands of researchers have spent thousands of hours here, and it is possible that a few of them have taken up eternal residence. Some say the ghost is a former librarian, but there is no history to support this view.

One student reports:

I spend a lot of time in Butler, doing research, and sometimes I get this feeling as if someone is nearby. I am sure it is a woman, and it's as if she knows I only want to do the best for the library. I feel she wants me to know that she is present, but there is a mutual respect of our space. Sometimes the hair on my neck prickles and she seems to follow me around. When I do leave, I believe she always walks me out safely, as if saying, "Goodnight and come back." I have never felt threatened, and she doesn't speak, but I do feel she is trying to communicate. She isn't troubled; she just cares.

Butler Library does not have the history of Sibley Hall or other, older parts of Lindenwood, but the stories cannot be ignored. In one case, "a column of gray smoke" was reported: "At first I thought the sump pump was on fire. The problem was that the vapor did not ascend upward or spread like the smoke of a fire. It just hovered there in one spot, and then vanished."

Lindenwood has been identified as one of the most haunted universities in the United States. Perhaps the location, in the haunted city of St. Charles, explains at least part of the activity. Many thousands of people have passed through the ivy-covered gates, and as time passes, more stories will no doubt emerge.

A LITTLE GIRL LOST

The ownership of 515 South Main reads like a who's who of St. Charles. The location was apparently first developed, in the form of a rude log structure, by Joseph Robidoux, a French fur trader. He sold the block to Charles Tayon on April 2, 1807, for $500 payable in skins. Tayon lived on the property for several years in a house that probably faced Pike Street. In 1821, William Eckert bought the block for $1,500, including the large frame house now located there. Eckert opened a tavern and hotel, and the entire block was known as Tavern Square. It was the center of town until the 1860s. The business was known as the St. Charles Hotel until Eckert's death in 1846. Local legend says that the Santa Fe Trail passed here, but in any case, it was a popular stop for stagecoaches and for people migrating to the west. Originally, the building was a large, two-story structure facing Main Street. The second story was destroyed in the 1867 tornado and rebuilt as it appears today.

The tavern was well known between 1818 and 1846, supported by the migration of various expeditions to the west. The Western House, at the corner of Boone's Lick Road and Main Street, was the starting site for the rougher crowd, but Eckert's Tavern was the starting site for the middle class, farmers and the more gentile.

In 1806, General Zebulon M. Pike left St. Charles and went up the Missouri and Osage Rivers. He then traveled overland westward to the Rocky Mountains. He had been commissioned to explore the western and southwestern parts of the Louisiana Purchase territory. In what is now

Eckert's Tavern as it appears today. *Photo by author.*

Colorado, Pike discovered the famous mountain peak that still bears his name, Pike's Peak. His expedition started at Eckert's Tavern. In a 1909 interview, William F. Broadhead noted:

> *At the time that St. Charles was the First State Capitol there were many Taverns, or Inns—they were never called Hotels in those days. One of the most popular was Eckert's Tavern which was near the old Methodist church. They were known as "The Sign of the Buffalo." Now you understand a great number of travelers passed through St. Charles at this time looking for a place to locate, and St. Charles was certainly the gateway to the west.*
>
> *The travelers bought tobacco, clothes, boots, shoes, wagons and horses. In practically every house, the people lived upstairs and sold their wares on the main floor. The Boone's Lick Road in my early days was the most traveled road in Missouri, crowded with travelers and stock.*

In 1820, a short distance south along Main Street, Boone's Lick Road was established "as a stagecoach worthy road to Franklin, Missouri." In 1825, President John Quincy Adams appointed Benjamin Reeves, George Sibley and Thomas Mathers as commissioners and instructed them to define the route to Santa Fe. Using Boone's Lick Road as the main highway, the Santa Fe Trail, the Salt Lick Trail and, finally, the Oregon Trail were established. These men assembled at Eckert's Tavern to write their reports concerning the survey and marking of the road from St. Charles to New Mexico.

William Eckert was an aggressive businessman, and he also operated a river ferry to bring more customers to his hotel. An article in the March

1838 Clarion newspaper shared the following review. The article could have been written last week; however, these days, you may want to bring your car. The stables are long gone.

> *Eckert's Tavern, the commodious public house with "the Sign of the Buffalo," has changed the name to St. Charles Hotel. It has been materially improved and thoroughly repaired and the whole establishment has been fitted up in such a manner as to render the situation of travelers comfortable and pleasurable. His table shall be bountifully supplied with the substantial necessaries and the luxuries of life.*
>
> *Skillful cooks and attentive well-trained servants will be provided and proper attention will be paid by the proprietor to the comfort of those who may favor him with their patronage. A full supply and a variety of choice liquors will be kept at the bar for those who may desire to indulge in that line.*
>
> *The stables are extensive and convenient and will always be well furnished and faithfully attended by experienced hostlers. Mr. Eckert solicits a share of public patronage and hopes to be able to serve you.*

The property was owned by William J. McElhiney, another prominent St. Charles citizen, from 1859 through 1875. From 1875 until about 1900, the building was used as a dentist's office and apothecary shop. About 1900, it was converted into a private residence.

In 1962, the St. Charles Historical Society purchased the building and converted it into a museum. Finally, in 1973, the historical society moved into the old city hall building, and the Eckert's Tavern building reverted to its original function. Today, once again, it is a restaurant and tavern.

Until 1949, there were additional buildings on the south side of the tavern. In that year, there was a fire, and in that fire a nine-year-old girl died. Interestingly, she did not live here. She lived up the street at 525 South Main, and there has always been some mystery surrounding her. Did she accidently start the fire or did she simply get trapped there? Actual records are vague, and this question will probably never be answered.

Today, there is a pleasant courtyard next to the building. It is an excellent location for a quiet (and tasty) meal; that is, mostly quiet. Many visitors have reported the presence of what seems to be a small child. They will feel an insistent pat on their leg or a friendly touch on their hand. A number of people have been affectionately hugged from behind. On several occasions,

The patio next to the tavern. The lost little girl is sometimes reported here. *Photo by author.*

someone's purse has been tugged from the arm of a chair, and on at least one occasion, food was stolen right off the plate.

In the spring of 2008, a customer reported the following incident:

> *We visit St. Charles every couple of years, and we usually stop here for lunch. The entire Main Street area is interesting, but there is just something special about this place. It has a feeling about it, a history.*
>
> *Last time we were here, some strange things happened. First, my purse started moving around. I thought it was the wind, but there was no breeze. As I watched, the flap on my purse opened, and it was if someone looked inside it, and then it fell off the arm of the chair. I did not touch it. The hair on my arms kind of prickled.*
>
> *A few seconds later, I felt a touch on my leg, as if someone was patting me, trying to get my attention. There was a child at a nearby table, and at first I thought perhaps the toddler was just being friendly. I turned that way, but the child was ten feet away and certainly not paying any attention to us. Actually, the child seemed to be a bit upset, frightened, and it pointed in our direction and said something about "little girl hurts."*

I told the server what happened and she said, "Oh, yes, she visits us sometimes, tries to get someone's attention. A few years ago, there was an accident here; a little girl was burned up."

It felt very creepy, but not really scary.

Gathering hard scientific data at this location is difficult. Photographs often show mysterious orbs and nebulous mists. However, there are many reflective surfaces in the courtyard—brass trim and such—and for the most part, everything mysterious in the photos has a conventional explanation. Evaluation of paranormal activity at this location is difficult. There are simply too many natural phenomena covering up and blending with what could be images of ghosts.

At least one professional paranormal investigation group has been here, but the results are inconclusive. Sensitives report an "energy," but nothing has been recorded on modern equipment. There are a number of photographs at this location, but everything in the images has a natural explanation.

THE RIVERBOAT CAPTAIN

This stretch of Main Street, from the Eckert's Tavern building at 515 south to the corner at 525, is very active. There are solid reports of two more ghosts here.

The owner of this shop tells the story of the riverboat captain who lived in the building at 525 South Main. More than one person has seen the spectral vision of him sitting in his rocking chair looking toward the river. It is said that while alive, his intent was to sit in his bedroom window and watch the river. He became quite irritated when the building across the street was erected because it blocked his view. Reportedly, he gently taps people on the shoulder and moves things around, leaving them in odd places. There are also reports of a creaking rocking chair, calliope music and the distant screech of a riverboat whistle.

A strange presence has also been reported in the dark, dank cavity in the rear yard, thought to be a slave tunnel. Late at night, clanks, moans and the odor of unwashed bodies have been experienced. There are no records about the tunnel—obviously, it would have been kept secret—but St. Charles was a significant stop on the trail to freedom, the Underground Railroad. This cavity is less than two hundred yards from the Missouri River. With a quick dash between buildings and a short boat ride, a runaway slave could

make his way into St. Louis County and freedom. Other than neighborhood stories, the actual function of the area is not known. It could have been a fruit cellar or part of a building that was destroyed long ago. It is just one more mystery we can add to the list of puzzles left behind on Main Street.

Until a few years ago, a clothing store was located at 525 South Main. As one would expect, the merchandise was displayed on racks and hung on the walls to entice customers. Employees and customers reported seeing what looked like a child playing between the racks. Clothing would move by itself and even occasionally fall to the floor. A longtime employee reported:

> *I would feel a slight draft, a cold draft, and a ripple would move down the rack, as if a child was in between the hanging clothes, just having some fun. One day, I told it to stop and get away from those dresses. The motion stopped immediately and the draft went away.*

The sales counter was by the front door, and near the cash register there was a toy antique sewing machine. According to the owner, the toy was found, neglected, in a storage area in an almost-empty box. It was in very good condition, and after it was cleaned up, it was displayed in the shop respectfully and proudly. The owners and the employees all knew the story; this was the home of the little girl who died in the fire down the street. It is widely believed that the sewing machine was a treasured toy of the sad, unidentified little girl. Perhaps someone could not bring herself to throw it out, but the sight of it was also painful. Apparently, it was carefully hidden away and forgotten.

More than once, when opening the store in the morning, the owners would find that the sewing machine had been moved. It would be found on a different counter or display case. On a couple of occasions, it was on a shelf—so high that they had to get a ladder to get it down.

A few years ago, the clothing store moved out of 525 South Main. The owner had a massive sale and sold everything down to the bare walls. The racks, the counters, the decorations and even the toy sewing machine were sold. The riverboat captain seems to still be here, but there have not been any reports of the little girl for several years now. There are no clothing racks, but there are many other tempting items on display.

Many people wonder, whoever bought the toy sewing machine, did they take the little girl ghost with it?

SHARE A GLASS OF WINE
WITH A GHOST

I have worked here for several years, and nothing strange happened, until the other night. A couple of us were cleaning up. I thought we were alone in the building. I was putting up chairs, and I heard something in the back storage room—voices.

It sounded like a couple of people, and I was a bit scared. Some customers left behind, perhaps. I listened closer, and I realized they were not speaking English. I had a bit of French when I was in high school, and I could hear the man saying, yelling actually, "Qui est-ce? Qui est-ce?" (Who is he? Who is he?) The woman kept saying, "Il n'y a personne!" (There is no one! There is no one!)

Then there was a loud crash, and the voices stopped. Later, when we gathered enough courage to go back there, a large tray of silverware was crashed on the floor, and several packages of napkins were ripped open. I don't know what happened, but something was there.

—eyewitness account of events at 501 South Main

The building at 501 South Main is comfortable and attractive. Ivy creeps up the walls on at least two sides, and the patio to the south is inviting and relaxing. Today, it is a winery and restaurant, but the location seems to have a slightly disturbing history.

This is the second location along Main Street that reports a form of the generic male and female ghosts. The history of the building is incomplete, but it is believed to have been built about 1880. No records with names of the owner or builder have been found. According to one account, the building

originally housed a saddler's shop, run by a French man and his wife. The area south of the building was a service area shared with the horseshoeing operation next door.

Local legend says that the Frenchman was a jealous man; his wife was young and beautiful, and he was older and plain. He was sure she was having an affair. One day, he confronted her and ended up beating her to death.

One longtime resident shared the following neighborhood story:

> *He made good saddles, but business was bad. People were starting to use cars, and good leatherwork wasn't needed so much. He had a pretty young wife, and he was always accusing her of stuff. Seems one day he lost his temper. We never saw either of them again. He just ran off. Figure he got on a boat or train and was gone. We think he buried her out in the service yard, but the horses churned everything up. We dug around a little bit but never found anything.*

The service area is now a pleasant patio. Ironically, many people describe it as romantic. It is shaded by old trees in the summer and warmed by open fires in the cooler months. It is a nice place to relax and share a glass of wine. Most guests never realize that there might be a body just below their feet. This area has been extensively excavated and landscaped, but nothing has ever been found. For that matter, there may never have been a saddle shop here.

Documents have been located that refer to a saddler's shop located at 112 South Main. It has no connection to this site, and there is no evidence of any scandal here. There could be some confusion about the functions of 501 South Main and 112 South Main.

The saddler located at 112 Main was owned by Edward Gut. In 1895, he employed eight men full time as saddlers. He is listed as having a high turnover of employees because his men could not work for many years due to the fumes they inhaled from the chemicals used in tanning leather.

In 1906, Gut took on a partner, Jacob Delger, and moved to a larger location—possibly 501 Main, hence the confusion. Edward Gut died in 1908, and Delger took on a new partner, Joseph C. Mertens. The newly formed Delger and Mertens Saddlery continued until about 1910, when automobiles became more popular and horses were replaced with motorcars.

Edward Gut and his wife were German, not French. They had two daughters and lived at 809 Clay Street. They never lived on Main Street.

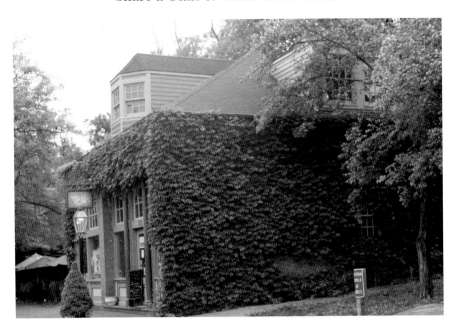

Winery of the Little Hills as it appears today. *Photo by author.*

Edward was elected mayor of St. Charles in 1889. He died quietly in his home on Clay Street. He certainly was not a murderer.

In any case, there is no shortage of strange stories connected to 501 Main. Another account tells of a suicide here. An unidentified man, possibly an itinerant, was "found hanging from the railing above the second floor." He is described as "dressed in shabby clothes and unwashed." A few years ago, a Main Street resident shared the following story:

> *I never seen him myself, but a couple of people that worked here told me about it. A couple of times, someone that had been drinking would look up and say, "What the hell is that?" No one else saw anything, but these guys would swear they saw a body hanging there. In the corner, just by the steps. Of course, they had been drinking, but you know, kids and drunks see things we don't see.*

There are almost no public records of this building. Of course, there are modern records, but these date back only to about 1930. Prior to that, the building itself is as much of a mystery as the stories reported here. The

restaurant has been here for more than thirty years. In 1980, the Augusta region became the first federally approved American viticultural area, eight months before the Napa Valley AVA in California. The wines produced for the restaurant come from this fifteen square miles (thirty-nine square kilometers) around the nearby city of Augusta.

The city of Augusta was founded in 1863 by Leonard Harold, a follower of Daniel Boone. It was originally named Mount Pleasant and had a riverboat landing known as Mount Pleasant. It was a short distance up the Missouri River from St. Charles, and the two cities have always maintained close ties.

In 1872, flooding caused the river to change course, leaving a distinct soil type behind in the area between the town and the river. The area's early vineyards were planted about 1880, and since then, a wine with "distinct flavor and profile" has been produced.

There were many wine producers in the area, and the two largest, August Winery and Mount Pleasant Winery, had direct connections to St. Charles. Around the turn of the century, one author wrote:

The wine industry was of the most importance. As Augusta was situated on a nice sunny south slope, and the land being very fertile, it was especially

The courtyard area of the winery. Is the missing wife buried here? *Photo by author.*

adapted to the growing of grapes. The entire area which is now the town property was once covered with vineyards, as were the surrounding hills. The principle [sic] kinds of grapes raised are the Catawba, Norton, Concord, Cassisy, Clinton, Herbemont and Hartford. Most of these varieties will average 500 to an acre.

It is possible that the previous building on this site had some connection to the area wine industry. In other words, this location may have a wine connection dating back many years. The growth of the grape and wine industry was rapid in the area, but the golden days did not last long. The downward trend began in 1884, when the owner of the Augusta Winery died. Documents indicate that the company did not have sufficient funds to pay the debts of the estate.

The reasons for the shortfall cannot be fully established, but there is an indication of problems with a leading salesman, referred to within the company as "Wine Fritz." His real name is not known. Apparently, Wine Fritz was careless when extending credit to out-of-town accounts and approving large sales to customers in Chicago whose businesses were wiped out by a large fire. Wine Fritz disappeared, and some people believe he committed suicide. Could the "shabby and unwashed figure" hanging in the corner be the spirit of the too-generous salesman?

CEMETERY SHADOWS

Some say the grounds here used to be part of the original Borromeo Cemetery. The exact boundaries of the old cemetery are not known, but until 1853, there was a cemetery along Main Street in this general area. Perhaps a few of these spirits remain uneasy and stir things up here.

Another story concerns shadowy visitors. In bright daylight, a group will gather on the sidewalk in front of the building and a few extra shadows will appear. One teenage girl relates:

We were just standing there on the sidewalk, waiting for Mom to come back with the car, and I was bored. There were eight of us standing there, and for some reason I started counting things, just because I was bored. There were three red cars nearby. Twenty-two people at tables inside the fence, and

our group cast ten shadows. That didn't soak in for a few seconds, but then I realized. There were eight of us standing on the sidewalk and there were ten shadows! I counted twice. Ten shadows. I touched my brother on the shoulder and told him about it. We both counted this time. Ten shadows.

I was scared and stepped out of the group. He counted again. Only seven shadows now, I had moved away from everyone else. He has never let me forget about this. He never misses a chance tell this story.

On quiet evenings, unexplained energy readings have been recorded. Investigators with EMF (electromagnetic force) detectors have reported very high readings. There is nothing in the courtyard to account for this energy, and it tends to manifest only when the courtyard is deserted or late at night. One local paranormal investigator told the following story:

I was standing near the fence, and the detector went off. It registered almost at the top of the scale. There is nothing in the area to account for this energy, no underground services, no electric lights, nothing. It reads about forty to fifty inches above the ground. I guess you could say about the same height of a person's heart—if a person was standing there.

I walked to the end of the fence and the reading just cut off. As if someone had thrown a switch, as if someone, or something knew where the fence was located. I cannot explain this phenomenon. I have never seen anything like it on any other investigation.

Investigators continue to look for records about 501 Main Street, and the mysterious stories connected to this site continue to accumulate. Strangely, no one seems to be frightened by the entities here. Perhaps the wine relaxes everyone. Perhaps the spirits are not that strong. Perhaps the history is wrong and the stories are just stories.

However, the reports continue. The French couple continues to argue, the shabby man still hangs around and extra shadows occasionally inhabit the sidewalks.

With that in mind, perhaps it is time to sit down here and share a glass of wine with a ghost.

A MYSTERIOUS COUPLE AND AN INCONVENIENT GRAVEYARD

Next to Berthold Square, at 217 South Main, is a dramatic three-story building with balconies overlooking Main Street. Originally, the building was part of a family business, but the structure is so cut up and modified that even the current owners don't know which parts are old and which are new. About 1890, Frederick Ebling built the house, and he lived here with his wife, Mathilda, for many years. He owned a tin shop on Second Street and was evidently quite successful. Reports describe them as a "quiet couple, keeping mostly to themselves."

Since then, the building has been many things. It was once a sheet metal fabrication shop, a paint store and, later, an automobile parts store. It has been a fancy house, an inn and, for the past forty years or so, a restaurant and a bar.

This is the third location on Main Street that reports some form of the male and female ghosts. In this case, it is a full manifestation.

Researchers agree that there are a number of ways to experience a ghost. The most common is through smell. This could be in the form of body odor, perfume, animal smells, leather or tobacco. Most people have probably experienced a ghost of this type but don't even notice. You may detect an odd odor but not connect it to an event. It hangs in the air like a little cloud, about the shape and volume of a person, but often the ghostly connection is not made. Many times, people report smelling grandma's perfume or father's pipe tobacco. Apparently, an olfactory

The Frederick Ebling Building as it appears today. *Photo by author.*

ghost requires the least energy and can make itself known with very little effort.

Another very common ghost is the proverbial "bump in the night." It can be as simple as a knocking or banging, but is often much more complex. Along Main Street, there is a location where reports of a baby crying in the middle of the night are common. Another building has occasional reports of a guitar playing, and in a third location there are reports of a couple arguing. Again, many people have experienced ghosts of this type but don't connect it to an event or history. They do not even realize that the sounds they hear may have been created by a ghost.

The holy grail of ghost hunting is the full manifestation. In spite of what the television shows would lead you to believe, a full manifestation is quite rare. Ghost stories are always stories, and as in any court, anecdotal stories are not acceptable evidence. The best evidence for ghosts is what is called "corroborating stories." This is when a number of people tell the same story. These stories agree in the details, but the people have not talked to one another. This evidence is impossible to refute and creates a strong case for the existence of the manifestations.

Just inside the front door of the restaurant is a service desk. There are always one or two employees stationed here to manage reservations and seat customers. It would be very difficult to sneak past the desk. Straight ahead, past the desk, is a stairway providing access to the upper floors. The stairway is not new; it was rebuilt a few years ago, but there have always been stairs at that location. Until recently, there was a door at the top of the first landing. When the building was functioning as retail space, this door provided access to storage rooms. When the new stairs were installed, this doorway was sealed.

Over the years, a number of people have told the same story. It always happens on a busy night. The stairs are almost blocked, full of people, difficult to get up or down. The hostess looks to the first landing and sees a couple, a man and woman, who did not check in at the desk. The man is always described as wearing a brown houndstooth jacket, and he has a handlebar mustache—an unusual detail. The woman—they never see her face—is said to have long, cascading dark hair. She is wearing a red satin dress. An interesting additional detail is that at least two of the people described the woman as possibly a prostitute.

Naturally, the hostess addresses the couple, "If you come back down here, I can seat you in a moment."

It's a busy night. The hostess turns her attention to the customers at the desk. When she looks back at the landing, the couple is gone. At least one person reported, "I watched them for a few seconds, and the man reached out, as if taking a doorknob, and they passed through the wall."

This man and woman remained unidentified. It cannot be Frederick Ebling and his wife; the clothing is wrong. It could be a guest from when the building functioned as a hotel or fancy house, but why would they stay behind? Were they victims of violence or is the place just special to them? Researchers have been unable to locate documents describing any crimes here, but the records are incomplete. There does not seem to be a pattern to the appearances; however, they seem to appear only when the restaurant and bar are busy. It is yet another mystery with the explanation lost in the mists of history.

In addition, the downstairs bar reports trouble with its television. On occasion, the television will simply shut off. It seems to happen when the bar is loud and full of energy, often during a popular sporting event. Everyone will be watching the action—a goal is about to be scored or runners are crossing the bases—and all of a sudden, the set turns off. Then the crowd

really gets excited. Patrons have been known to throw things. In fact, in the last few years, the restaurant has replaced the television above the bar more than once. It doesn't seem to matter. The television shuts down, usually at the least convenient moment, at least two or three times a year.

A short time ago, a young girl, twelve or thirteen years old, approached a tour guide with the following story: "A few weeks ago, we were in here, it was real busy and we were waiting for our table. The bar was real loud and people were yelling at the TV and all of a sudden the TV turned off and they got really mad!"

Again, perhaps a corroborating story. Researchers are keeping track of these events, but there doesn't seem to be much of a pattern. The only common factor seems to be a loud, rowdy sporting event. Perhaps this ghost is trying to join in the fun, or maybe he just hates sports.

Have you ever seen a dog or cat examine something that was not there? Sometimes a cat will actually attack some invisible object. A dog may sit and stare, or even bark and growl, at something we don't see. Dogs and cats—and digital cameras—see farther into the infrared. Sometimes when a cat or dog acts like they see something they actually *are* seeing something invisible to people. When the bar is full of energy, is a phenomenon coming through in the infrared?

According to the laws of physics, energy has to come from somewhere. Many researchers believe that we are seeing more and more paranormal objects because we are providing easily tapped sources of energy. In the past, during an encounter people would often report a "cold spot" or perhaps a heavy feeling in the air. Today, we have electrical energy in the walls, cellphone batteries, camera batteries and large-screen televisions. The energy in these devices is much easier to utilize. Also, in modern buildings the environment and temperatures are tightly controlled. Why should a ghost borrow heat energy from the air when all it has to do is steal power from your cellphone?

Many people have unexplainable photographs of orbs and other flashes of energy. Again, these objects tend to appear in digital cameras because of their ability to see beyond visible light. In the bar at 217 Main, paranormal investigators speculate about a manifestation coming through in the infrared. Infrared signals are often used in television remote controls. Perhaps this energy coming through hits the TV controls, shutting it down.

An Inconvenient Graveyard

It is in the best interests of an investigator to keep track of buildings in the area that are gone, missing or destroyed. Did the building burn down or fall down or was it stolen by aliens? There is a small city park just south of 217 Main Street. For a long time, no records of any buildings there could be located. A few years ago, records finally came to light. There never was a building here. Until about 1850, the small city park was a private cemetery.

Dr. Jeremiah Millington came to St. Charles about 1799. He was the first physician to locate in St. Charles County. He came from Herkimer County, New York, with his two brothers, his mother and his sister. He was educated and wealthy and soon became the largest landowner in the area. Jeremiah and his brother Seth were joint owners in a botanical garden west of the city.

Records show that he and his brother planted fifty acres with bean plants in 1802. These beans were used to produce castor oil. By 1803, St. Charles had become the center of the castor oil industry. In those days, doctors made their own medicines, and castor oil was considered an almost-magical cure for a number of internal maladies. They manufactured and distributed the first commercially produced castor oil, and essentially it was the petroleum of its day.

In 1803, Dr. Millington wrote in a letter:

> *This Castor Plant grown here had the luxuriant appearance of the bean plant. It's wide spreading leaf and large stalk is not inferior in richness of appearance to the sugar cane of Louisiana.*
>
> *We are able to supply the western country with the valuable medicine of Castor Oil having a surplus left which we transport to New York and New Orleans amounting yearly to several thousand dollars, which may be considered a complete savings to that country. We employ the year round sixty people in this our castor oil venture.*

Usually, the castor bean is grown in warm countries, but the Millingtons decided to try it here. Their experiment was a huge success. The golden oil was very popular. According to the Lewis and Clark diaries, the explorers purchased a quantity of castor oil in bottles to keep their men well.

In 1820, the Millingtons discovered coal on their property, near Harvester Road, and they opened the first coal mine in the area. The coal was called

stone coal and was reported to be of the highest quality. Prior to this, all heating was done with wood. The brothers promised free coal to heat the capitol building, and this was an important factor in bringing the state government to St. Charles. The mine was closed in 1830 after a serious cave-in in which several people were killed.

By all accounts, Dr. Millington was greatly loved. He covered great distances with his team of fine horses. One record tells of a childbirth, "rather a distance from town." He received "two dollars and a couple of chickens" for the treatment.

Dr. Millington lived down the street from the graveyard at 322 South Main Street. This building is described as a dignified English-style home. "It is made lovingly of handmade brick, with the stone cornices of the windows typical of English architecture." The main part of the building was erected in 1811, just before the earthquakes that devastated southern Missouri, and was probably damaged and repaired at that time. The front portion was added in 1820.

Jeremiah's brother Seth ran a wheelwright shop down the street, "just below the Kentucky hotel." A short time later, he converted the shop to a silk factory. He decided to raise silkworms, assuming that if the weather was good for castor oil, silkworms would also thrive. He was going to produce the first silk in this part of Missouri. However, records show that this silk adventure was a total loss. It was one of the few failures of the Millington clan.

In general, the Millingtons were a remarkable family. Dr. Jeremiah was appointed postmaster on January 27, 1823, and served until July 14, 1826. In other words, he was postmaster while St. Charles was the first state capital of Missouri. His postal duties were carried out in the capitol building, along with his medical practice, offices for the coal mining operation and the sales office for the castor oil business.

Records show that the castor oil factory closed its doors because of the cholera epidemic that devastated St. Charles in 1833–34. In July 1833, more than one hundred people died in St. Charles. In 1834, Dr. Seth Millington, Sylvia Millington French and Dr. Jacob Millington were lost. With so many of the Millingtons dying, the castor oil factory closed its doors. The last record shows a shipment of oil to New Orleans in 1835.

The Millington Cemetery was directly across the street from the first capitol building. If one was wealthy enough or considered to be sufficiently

important in the St. Charles community, he could be buried here, but all arrangements had to be made through Dr. Jeremiah Millington. One could buy a coffin from him and a headstone, and the good doctor would arrange for the ceremony. It is believed that perhaps twenty people were buried here at its peak.

Sometime around 1850, the property became very valuable. Dr. Millington sold the property, probably at a significant profit, dug everyone up and moved the bodies to the Oak Grove Cemetery west of St. Charles. No one was left behind.

When Seth Millington died in 1834, he was buried here, in the Millington Floral Garden. When the property was sold, his tombstone was too large to move, so it was broken up and thrown into the Missouri River. His remains were disinterred and reburied with the others at Oak Grove. No tombstone was placed at the new site, and the location of his grave has been lost.

Today, many people feel that the location still looks like a cemetery. Comfortable benches, attractive landscaping and a winding walkway complete the picture. People sit, relax and perhaps read a book or newspaper.

Most do not realize that this pleasant park was once a small necropolis.

THE OLD FARMER'S HOME

Almost every building on South Main Street has a story to tell. The building at 700 South Main, known as the Farmer's Home building, seems to have more than its share. The building is old, and many people have lived here. Unfortunately, much of the site's history has been lost or distorted over the years. It is known that the current building dates back to at least 1821 in some form and could date to as early as 1805.

According to records, the northern half of block 18 was a twenty-seven-vat tanning yard. It contained a number of different buildings, and in 1810, it was owned by Missouri's first governor, Alexander McNair. In 1811, Don Tayon became the owner. He was the second commandant while St. Charles was under the control of the Spanish.

John Frazer (also spelled Fraizer) took over in 1822 and built additional structures on the block at that time. These structures are gone, and records about them are quite vague. The tax ledger shows an increase in 1823, a good indicator of new buildings, and a decrease a few years later. It is believed that one or more of these buildings burned down during that time and were not rebuilt.

The Farmer's Home building has been modified and was possibly rebuilt before Christian Weye bought it in 1854. At that time, Weye made extensive repairs. Weye named it Farmer's Tavern and lived there with his family. It remained a tavern until Prohibition (1925). The name "tavern" is a poor indicator of the importance of this location in the nineteenth century. It also

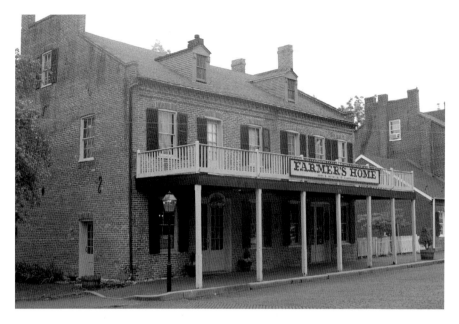

John Dengler's building as it appears today. *Photo by author.*

functioned as an inn for travelers coming through St. Charles headed west. A ferry, taking people and goods across the Missouri, operated at the foot of nearby Perry Street. As a result, 700 South Main was a prime location for a hotel.

St. Charles was surrounded by prosperous farms. When the farmers came to town to sell their products, this tavern was a favorite stopping place. In front of the tavern was a deep well. A large bell hung on the post near the pump. When a farmer arrived, he would ring the bell to summon an "ostler" (hostler without the "h"). The ostler watered the horses and took them to the rear of the tavern, where, according to advertisements, there was "a large covered stable."

A recent visitor (2008) from the East Coast reported:

> *It was a hot day, and I was getting a bit tired. My wife wanted to look at a couple more shops so I sat on the bench in front of the tobacco shop. I might have dozed off a bit, but I swear I heard horses just in front of me. I looked up, expecting to see the carriage ride in front of me, but it wasn't there. Then I heard, clear as anything, a bell ringing. It rang three times, but there isn't a bell anywhere around here!*

Farmer's Tavern has passed through many owners. According to records, in 1849 it was owned by Melchion Thro. During his ownership, newspapers tell of a city park near the tavern. Often, when the tavern was busy, patrons would move to the park to socialize. It became so popular that it was soon nicknamed "City Loafer's Park." Some nearby businesses complained, but Mr. Thro defended the practice. Apparently, most of the loafers were his customers.

Usually, Missouri taverns were named after the owners, such as Eckert's Tavern just down the street. As products of the pioneer community, tavern keepers were at the top of the social scale. Taverns were places for travelers to stop and for the weary to find solace, good food and pure water. When St. Charles attained the status of a metropolis, taverns gradually changed, becoming "homes." The name of the Farmer's Tavern soon changed to the Farmer's Home.

In 1856, Christian Waje bought the Farmer's Home. The St. Charles Reveille newspaper, dated September 1856, tells of Mr. Waje making many improvements and changing the name to Farmer's Home. He had six sons and what was described as "a beautiful daughter." Sadly, the daughter died when she was only seven years old. The entire town turned out for her funeral. She was one of the first to be buried in the new Borromeo Cemetery, just outside of town.

Many stories surround this old and popular building. It seems that something was always happening here. A newspaper article on February 26, 1876, reported:

> *Yesterday a terrible tornado struck St. Charles. The Farmer's Home Tavern was among the buildings damaged. The large stable was completely destroyed. The North end of the building was completely blown away. A man by the name of Aug. Sling, one of the town loafers, was taking refuge in the stable. He was clinging to a door and the man dropped in the street, 50 feet away and he was not even scratched or bruised.*

Since 1927, this building has been the home and business of John Dengler. Sadly, John died a short time ago. He was eighty-two years old. He had a long and productive life, but he is missed. He is one of the people directly responsible for the current condition of St. Charles's Main Street. His efforts helped to turn a seriously declining area into what many call a tourist mecca.

You will find a friendly wooden figure in front of the current tobacco shop. *Photo by author.*

John's father also ran a tobacco shop here. It is located in what was the ladies' dining room of the inn. Sometimes, even above the pleasant odor of the tobaccos, visitors say they smell ham and beans. When the building was functioning as an inn, ham and beans were often served. This dish could be prepared quickly and in large quantities. Travelers would often stop here for a quick, filling and inexpensive meal. Tru, John's wife, once said, "Perhaps the upstairs ghost cook wants to make sure the ghosts that are passing through can still get a good ghost meal."

Tru passed a few years ago, but her favorite story was about what she called the "impatient salesman." John was very active in the St. Charles

business community and often would come home rather late. As Tru relates, she would be home alone, waiting for John, and she would hear someone banging on the downstairs door, calling her name. Assuming John had locked himself out again, she would go downstairs, but when she got to the front door, no one was there. Then, after a few seconds, someone would be banging on the upstairs balcony door, calling her name. She would go up there—again, nothing. This would continue three or four times, until one or the other got tired of the game.

"It was just like someone wanted to sell me something or deliver something," she said. "But he never stuck around long enough to talk to me."

Tru also reported strange phone activity. "I would hear the phone ring twice, then when I went to answer it, I discovered that the handset was off the hook," she said. "There was no way it could have rang, and no one else around to take it off the hook. Out of everything that happened, it was the phone thing that really gave me the willies."

An active and popular place for its entire history, there are many stories based at the Farmer's Home. One tale talks of a duel on the stairs leading to the upstairs rooms. Ghostly figures are reported, swords in hands, fighting up and down. This could be the stuff of a good (or bad) Errol Flynn movie. There are many stories about duels in the St. Charles area. The early city residents, and visitors, must have been hard, seasoned people. Beyond any doubts, there were shootings, assaults and probably more than one duel. Still, there is no hard evidence to support this—any duels would have taken place out of town, out of sight. But there is some evidence to suggest that there was a dueling field just behind the capitol building, a short distance to the north. If there actually was a confrontation here, it would probably have been an assault or robbery. However, who can resist the romance of a duel? It's much more fun, ghostly and makes a better story than a common crime.

Records list the Farmer's Tavern as a popular gathering place. In an advertisement dated 1821, we learn that J.J. Dozier was the owner. The state capital offices had just opened, and obviously a new business opportunity presented itself. To quote the advertisement:

> *I invite the Legislators to board at my Farmer's Tavern. Lodging, two bits a night. I specialize in good food. Corn Bread and common fixings, two bits a meal. Ham and beans, two bits a meal. White bread with chicken fixings, three bits or 37 a meal.*

John and his wife used the second floor of the building as living quarters, and in addition to his tobacco shop, he rented space to other businesses on the first floor. Other people in the building have had strange encounters that are difficult to explain. One woman, who was renting the space next to the tobacco shop, once accused John of playing a prank on her. She was walking down a staircase in the back of the building and distinctly felt a hand on her shoulder. Then a voice whispered eerily in her ear, calling her name. Startled, she hurried down the steps to find Dengler just walking in the door. He had been at a meeting that had kept him out of the building all morning. At first she assumed he had played a trick on her, but she quickly realized that she had no explanation for what had just happened.

Several people have also heard heavy footsteps on these same stairs and in the hallways of the building. Dengler's daughter, Laura, was once terrified by the sound of laughter that came from nowhere. John and Tru once had a strange experience while painting and restoring the upstairs living area. In 1982, John told a local newspaper:

> For about four days, a French-speaking apparition seemed to delight in playing tricks of floating cigarette packs in the air and hiding them. Unexplainable too was how the radio talk show would suddenly be switched to rather unusual classical music without the dial being changed. On the fifth day, a baby was heard to be crying, whereupon it was soothed by a calming French voice.

Also, during the renovations, John and Tru would find a neat little pile of torn-up wallpaper lying on the floor in the middle of the room. "It was like old-fashioned wallpaper, not like anything we had in the building," they said.

There is more activity, much more, reported on this site. In the upstairs apartment, a puddle of water occasionally appears in the middle of the kitchen floor. At first, the family cat was blamed for not using his litter box. Ceilings were checked, plumbing was checked and no leak was discovered. The refrigerator was checked, but the refrigerator is several feet from where the water appears. Finally, after testing the water, it was found that the puddle was pure water—no contamination from outside or from plumbing. There is no logical explanation for the existence of the puddle. It has been seen several times since then.

Inside the main tobacco shop, there are cabinets used to store the premium pipe tobaccos. The product is stored in big glass jars with a latch to hold them

closed. John reported that, more than once, he would open the cabinets and it was as if someone had sampled the product. There would be little piles of tobacco on the front edge of the shelves. He also pointed out that only the cherry-flavored tobacco would be sampled. If he rearranged the stock, next time it happened, the cherry-flavored tobaccos would be disturbed once again. "First of all," he said, "rats and mice and bugs are not interested in tobacco. In some cases it poisons them." He finished with a grin, "Besides, I don't think they could get those jars open."

In 1994, John's daughter held a séance with a Ouija board. "We asked if he was a good ghost or a bad ghost," she said.

> *He said he was a good ghost. We found out his name was Albert. He was a Confederate officer who had been imprisoned by the Union army at what is now the Trailhead Brewery on Main Street. The building was used as a Union prison during the Civil War. We asked Albert if he had owned slaves. He said, "Yes, as many as I could get my hands on." We asked him what he was doing in our building. He said he was the "protector of the building." We have not heard much from him since then.*

Sometime about 1985, a man with a toddler was standing in the hall, waiting for his wife. There was a heart-shaped woven-wheat decoration hanging on the wall. The man came running into the main shop, all excited. He said the weaving had floated off the wall and come to him. He grabbed it with his hand as it floated through the air.

When it comes to research or stories about old St. Charles, John Dengler was everyone's first stop. He always knew the names, dates and places. He could share with you the joys of marriages, births and anniversaries. He also knew where a few of the skeletons—literally—were buried. He spent many years on Main Street and kept so much history in his memories. John's son-in-law, Larry Muench, is taking over the business, and Farmer's Home will stay open. In fact, it is hoped that, with as long as John lived here and as strong as his spirit was, perhaps before long, we will hear some stories about John.

Who can say how many people passed through these doors? Names are lost in history. Most passed through without incident, but there must have been a few interesting inhabitants—people on the run, people broken and moving west to a new life and perhaps even a few tragic lovers.

So, other than perhaps John, who are the ghosts that haunt the Farmer's Home building? Are they former guests of the hotel or the spirits of those left behind in the nearby old St. Borromeo Cemetery? Research indicates that the French ghost may be Antoine Marechal, one of the building's original owners. We will never know, but most people say they are welcome to stay.

"But they've got to behave themselves," they add with a smile.